Rob Sheppard
CANON EOS 50D

Magic Lantern Guides®

Canon EOS 50D

Rob Sheppard

A Division of Sterling Publishing Co., Inc.
New York / London

Editor: Rebecca Shipkosky

Book Design and Layout: Michael Robertson

Cover Design: Thom Gaines

Library of Congress Cataloging-in-Publication Data Sheppard, Rob.

Canon EOS 50D / Rob Sheppard. -- 1st ed. p. cm. -- (Magic lantern guides)

Includes index.

ISBN 978-1-60059-526-4 (pbk.: alk. paper)

1. Canon digital cameras--Handbooks, manuals, etc. 2.

Photography--Digital techniques--Handbooks, manuals, etc. 3. Photography--Handbooks, manuals, etc. 4. Single lens reflex

cameras--Handbooks, manuals, etc. I. Title.

TR263.C3S5227 2009

771.3'2--dc22

2009003803

10987654321

First Edition

Published by Lark Books, A Division of Sterling Publishing Co., Inc. 387 Park Avenue South, New York, N.Y. 10016

Text © 2009, Rob Sheppard
Photography © 2009, Rob Sheppard unless otherwise specified

Distributed in Canada by Sterling Publishing, c/o Canadian Manda Group, 165 Dufferin Street Toronto, Ontario, Canada M6K 3H6

Distributed in the United Kingdom by GMC Distribution Services, Castle Place, 166 High Street, Lewes, East Sussex, England BN7 1XU

Distributed in Australia by Capricorn Link (Australia) Pty Ltd., P.O. Box 704, Windsor, NSW 2756 Australia

This book is not sponsored by Canon.

The written instructions, photographs, designs, patterns, and projects in this volume are intended for the personal use of the reader and may be reproduced for that purpose only. Any other use, especially commercial use, is forbidden under law without written permission of the copyright holder.

Canon, EOS, Rebel, and other Canon product names or terminology are trademarks of Canon Inc. Other trademarks are recognized as belonging to their respective owners.

Every effort has been made to ensure that all the information in this book is accurate. However, due to differing conditions, tools, and individual skills, the publisher cannot be responsible for any injuries, losses, and other damages that may result from the use of the information in this book. Because specifications may be changed by manufacturers without notice, the contents of this book may not necessarily agree with software and equipment changes made after publication.

If you have questions or comments about this book, please contact: Lark Books 67 Broadway Asheville, NC 28801 (828) 253-0467

Manufactured in the Unites States of America

All rights reserved

ISBN 13: 978-1-60059-526-4

For information about custom editions, special sales, premium and corporate purchases, please contact Sterling Special Sales Department at 800-805-5489 or specialsales@sterlingpub.com.

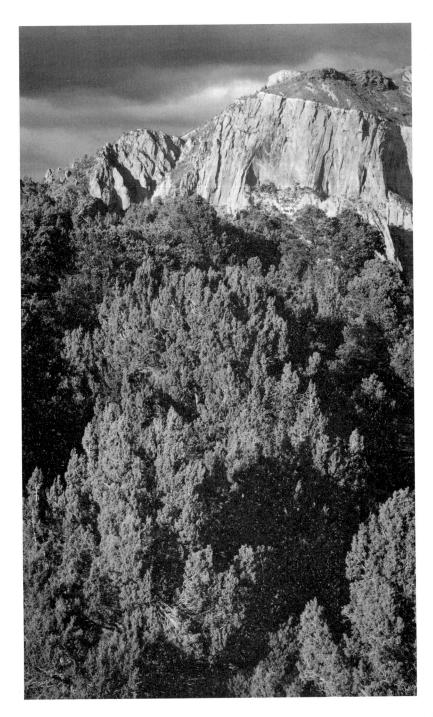

Contents

A Continuing Evolution
Reviewing the Differences Between Film and Digital
Film vs. the Sensor 17
The LCD Monitor18
Memory Cards19
Exposure
ISO Sensitivity
Noise
File Formats
Digital Resolution24
The Color of Light26
Cost of Shooting
Features and Functions
Camera Nomenclature
Overview of Features
Camera Controls
Main Dial 38
Quick Control Dial38
Multi-Controller38
Shutter Button40
Camera Activation 40
Three-Position Poser Switch
Sensor Cleaning40
Auto Power Off 41
Resetting Controls
The Viewfinder
Viewfinder Adjustment43
Viewfinder Nomenclature44
The LCD Monitor45
The Live View Function47
LCD Panel Nomenclature 50

The LCD Panel	
Power	
Date/Time	
The Sensor and Processor	
Cleaning the Sensor	59
Mirror Lockup	61
Memory Cards	62
Working with Memory Cards	63
Organizing Images on the Memory Card	64
Formatting Your Memory Card	65
Erasing Images from Your Memory Card	66
Erasing Images from Your Memory Card	66
D. C.	60
In-Camera Processing and File Formats	71
Picture Style	71
Changing Picture Style Settings	75
Changing Monochrome Settings	77
User-Defined Picture Styles	77
Picture Style Editor	7.0
White Balance	20
What is Color Temperature?	
White Balance Settings	
White Balance Correction	
White Balance Auto-Bracketing	80
Color Space	89
Clarify a Consequence Settings	01
Checking Camera Settings The 50D File Formats	91
RAW Exposure Processing	93
Image Recording Quality	95
File Quality and Card Capacity	96
File Quality and Card Capacity	50
Camera Menus and the LCD Monitor	99
Navigating the Menus	. 99
Shooting 1 Menu	101
Shooting 2 Menu	102
Playback 1 Menu	102
Playback 2 Menu	102

set-up i Menu	
Set-up 2 Menu	. 103
Set-up 3 Menu	. 103
Custom Functions Menu	
My Menu	. 104
Custom Functions	. 105
C.Fn I: Exposure	. 106
C.Fn II: Image	. 109
C.Fn III: Autofocus/Drive	. 111
C.Fn IV: Operation/Others	. 114
The LCD Monitor	. 117
LCD Instant Image Review	. 118
Playback	. 119
Automatic Image Rotation	. 121
Magnifying the Image	. 122
File Numbering and New Folders	. 122
Protecting Images	. 124
Erasing Images	. 125
Slide Shows from the Camera	. 126
TV Playback	127
TV Flayback	. 12/
ту глаураск	. 127
Camera Operation Modes	. 129
Camera Operation Modes Focus	. 129 . 129
Camera Operation Modes Focus	. 129 . 129 . 131
Camera Operation Modes FocusAF ModesSelecting an AF Point	. 129 . 129 . 131 . 132
Camera Operation Modes Focus AF Modes Selecting an AF Point AF with Live View	. 129 . 129 . 131 . 132
Camera Operation Modes Focus AF Modes Selecting an AF Point AF with Live View AF Limitations	. 129 . 129 . 131 . 132 . 133
Camera Operation Modes Focus AF Modes Selecting an AF Point AF with Live View AF Limitations AF-ON Button	. 129 . 129 . 131 . 132 . 133 . 135
Camera Operation Modes Focus AF Modes Selecting an AF Point AF with Live View AF Limitations AF-ON Button Drive Modes and Self-Timer Control	. 129 . 129 . 131 . 132 . 133 . 135
Camera Operation Modes Focus AF Modes Selecting an AF Point AF with Live View AF Limitations AF-ON Button Drive Modes and Self-Timer Control Exposure	. 129 . 129 . 131 . 132 . 133 . 135 . 136
Camera Operation Modes Focus AF Modes Selecting an AF Point AF with Live View AF Limitations AF-ON Button Drive Modes and Self-Timer Control Exposure ISO Sensitivity	. 129 . 131 . 132 . 133 . 135 . 136 . 137
Camera Operation Modes Focus AF Modes Selecting an AF Point AF with Live View AF Limitations AF-ON Button Drive Modes and Self-Timer Control Exposure ISO Sensitivity Metering	. 129 . 129 . 131 . 132 . 135 . 135 . 136 . 137
Camera Operation Modes Focus AF Modes Selecting an AF Point AF with Live View AF Limitations AF-ON Button Drive Modes and Self-Timer Control Exposure ISO Sensitivity Metering Judging Exposure	. 129 . 129 . 131 . 132 . 135 . 135 . 136 . 137 . 138 . 141
Camera Operation Modes Focus AF Modes Selecting an AF Point AF with Live View AF Limitations AF-ON Button Drive Modes and Self-Timer Control Exposure ISO Sensitivity Metering Judging Exposure Highlight Tone Priority	. 129 . 131 . 131 . 132 . 133 . 135 . 136 . 137 . 138 . 144 . 144
Camera Operation Modes Focus AF Modes Selecting an AF Point AF with Live View AF Limitations AF-ON Button Drive Modes and Self-Timer Control Exposure ISO Sensitivity Metering Judging Exposure Highlight Tone Priority AE (autoexposure) Lock	. 129 . 129 . 131 . 132 . 133 . 135 . 136 . 137 . 138 . 141 . 144 . 149
Camera Operation Modes Focus AF Modes Selecting an AF Point AF with Live View AF Limitations AF-ON Button Drive Modes and Self-Timer Control Exposure ISO Sensitivity Metering Judging Exposure Highlight Tone Priority AE (autoexposure) Lock Exposure Compensation	. 129 . 129 . 131 . 132 . 133 . 135 . 135 . 136 . 137 . 138 . 141 . 144 . 149 . 150
Camera Operation Modes Focus AF Modes Selecting an AF Point AF with Live View AF Limitations AF-ON Button Drive Modes and Self-Timer Control Exposure ISO Sensitivity Metering Judging Exposure Highlight Tone Priority AE (autoexposure) Lock Exposure Compensation Autoexposure Bracketing	. 129 . 129 . 131 . 132 . 133 . 135 . 136 . 137 . 138 . 141 . 144 . 149 . 150 . 151
Camera Operation Modes Focus AF Modes Selecting an AF Point AF with Live View AF Limitations AF-ON Button Drive Modes and Self-Timer Control Exposure ISO Sensitivity Metering Judging Exposure Highlight Tone Priority AE (autoexposure) Lock Exposure Compensation	. 129 . 129 . 131 . 132 . 133 . 135 . 136 . 137 . 138 . 141 . 144 . 149 . 150 . 151 . 152

Auto Brightness and Contrast Correction	137
Creative Zone Shooting Modes	158
Choosing Shutter Speeds	164
Flash	169
Using Flash	170
Flash Synchronization	172
Guide Numbers	173
Built-In Flash	174
Flash Metering	175
Flash with Camera Exposure Modes	177
Program	178
Shutter-Priority	178
Aperture-Priority	178
Manual	179
Flash Exposure Compensation	180
First and Second Curtain Flash	180
Red-Eye Reduction	181
Canon Speedlite EX Flash Units	182
Canon Speedlite 580EX II	183
Canon Speedlite 430EX	185
Canon Speedlite 430EX II	186
Canon Speedlite 220EX	186
Other Speedlites	186
Macro Twin Lite MT-24EX	186
Macro Ring Lite MR-14EX	186
Wireless E-TTL Flash	. 187
VVIICICSS E TTE TIUSH	
Lenses and Accessories	. 189
Choosing Lenses	. 190
Zoom vs. Prime Lenses	. 191
EF-Series Lenses	. 192
EF-S Series Lenses	. 193
L Series Lenses	. 194
DO Series Lenses	. 195
Image Stabilizer Lenses	. 195
Macro and Tilt-Shift Lenses	. 197
Independent Lens Brands	. 197
macpendent Lens Blands	

Filters and Close-Up Lenses	198
Polarizers	198
Neutral Density Gray Filters	199
Graduated Neutral Density Filters	199
UV and Skylight Filters	199
Close-Up Accessories	200
Tripods and Camera Support	204
Working with the Computer	207
Direct from Camera	207
The Card Reader	208
Organizing Digital Image Files	209
Browser and Cataloging Programs	212
Image Processing	213
Digital Photo Professional Software	214
Storing Your Images	214
Direct Printing	216
Digital Print Order Format (DPOF)	219
Index	220

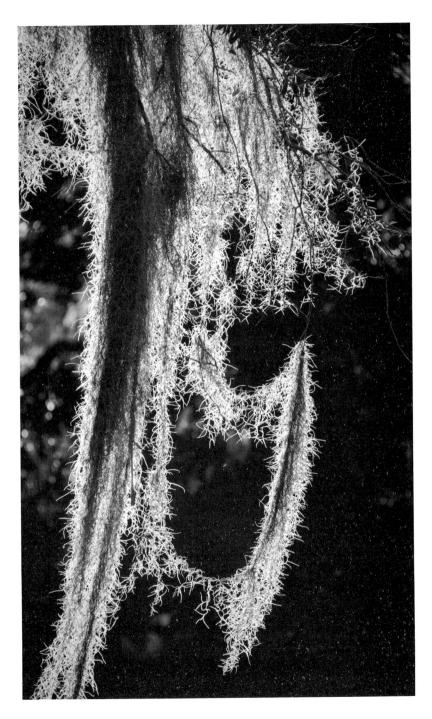

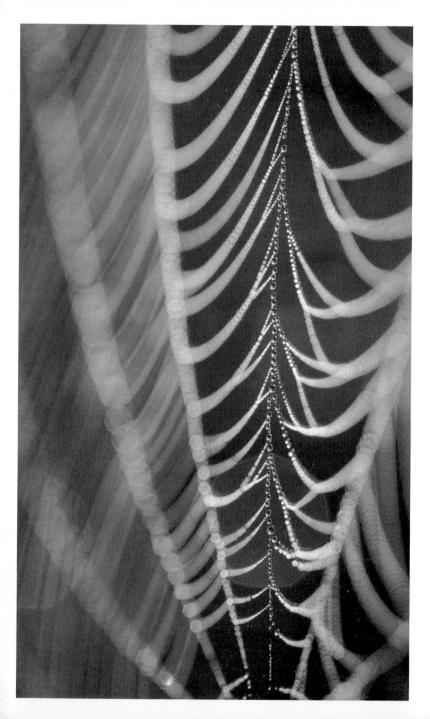

A Continuing Evolution

You now have an excellent camera in the Canon EOS 50D. But obviously having a good camera and getting good pictures can be two different things. This book is designed to help you understand the features of the 50D so that you can get the most from it. Furthermore, this book is meant to be an extended instruction manual for the EOS 50D. It covers some of the material that is in the manufacturer's manual,

The latest photographic technologies and sophisticated features found in your Canon EOS 50D will help you capture the wonder and beauty all around that is waiting to be recorded.

Check out the Insider View sections throughout the book to give you special insight on camera features and working with the 50D.

but includes quite a bit more in terms of photographic information to help you take advantage of what this camera has to offer. In fact, I have added insights and analysis that were not part of other Canon Magic Lantern Guides—a little more perspective. Sure, previous guides examined a particular control and told you how to operate it, but now I am going further to offer ideas based on my long experience working with digital SLRs (D-SLRs) and in digital photography.

The "Insider View" notes found throughout this guide will alert you to personal observations on how you can get the most out of a particular feature. Overall, this guide will help you better use the Canon EOS 50D. The 50D continues the evolution of mid-priced Canon digital SLRs from the 10D to the 20D to the 30D to the 40D; in many ways, it is a seriously upgraded 40D. If you understand the 40D, you will understand the 50D. They are nearly identical in terms of basic operation. The 40D was the first in this price range to offer 14-bit capture capability, and had a 10.1 megapixel sensor, an increase of nearly

20% over the 30D. The 50D continues the 14-bit capability, but now ups the sensor size to a remarkable 15.1 megapixel CMOS sensor, a nearly 50% increase over the 40D! It is important to note that megapixels are not everything when it comes to image quality, and extremely high resolution on a small sensor can even cause a reduction in image quality, but Canon has managed to increase the number of pixels without making that sacrifice. The camera also includes a remarkable 6.3 frames per second (fps) shooting speed, a high-resolution LCD far superior to the 40D's monitor, Live View that uses that resolution and includes better autofocus functions, and offers self-cleaning sensor capabilities (the same as the 40D).

Note: Throughout this guide, when the terms "left" and "right" are used to describe the locations of camera controls, it is assumed that the camera is being held in the shooting position, unless otherwise noted.

Insider View: See? Here's the first Insider View! The fact that Canon increases the number of pixels by almost 50 percent means there are a lot of pixels on the APS-C-size sensor. In the past, that would've meant lower image quality, particularly an increase in noise. Canon has worked hard to prevent that from happening, so that image quality remains high along with more megapixels. Digital SLRs were all 12-bit cameras before the Canon Mark III series. The EOS 40D brought that capability into an affordable camera, which is retained in the 50D. You cannot really see much difference when you look at 8-bit (like IPEG files), 12-bit, and 14-bit images. The difference comes in the processing. Each higher bit-depth offers an exponential increase in data that can be used to get a better-looking image. This results in the ability to get better tonality and color gradations when shooting in RAW. However, that doesn't mean JPEGs are unaffected, because a JPEG file is a RAW image processed by Canon's DIGIC 4 chip. So with more data to work with, even in-camera processing has the potential for better looking photos. Megapixels are not everything in image quality—higher bitdepth offers the possibility of much higher image quality than just a higher megapixel count.

Canon's self-cleaning sensors are very important. Sensor dust has consistently plagued digital photographers, creating annoying dark spots on a photo. This self-cleaning sensor will not eliminate dust completely (you will need to blow out the mirror box of the camera regularly), it makes dust a much smaller problem.

One feature that you will definitely like is the high resolution LCD. This makes the images displayed on the back of your camera so much better-looking and easier to evaluate. All of these factors make the Canon EOS 50D an excellent upgrade from the 40D camera.

While designed to meet the requirements of advanced amateurs, the 50D is definitely attractive to pros as well because of its size and high-quality APS-C sensor. In some ways, this makes the camera a little schizophrenic: There are several functions that few amateurs will use, and some features in which pros will have little interest. This book covers them all, however, because all of these features make this a very powerful camera.

Just like the 40D, the 50D also has many similarities to the EOS-1D Mark III and EOS-1Ds Mark III in the way it handles. To be sure, the Mark IIIs are much bigger cameras, but the types of controls (like the AF-start button on the back) and the way in which they function are very similar. This makes the 50D attractive to professionals, especially as a companion camera to the EOS-1D Mark III.

Many photographers will have purchased the 50D as an upgrade from earlier EOS D-SLRs. For some, however, this is their first high-quality digital camera. Since a number of readers are new to D-SLR photography, this book will explain an assortment of topics that are basic to experienced digital photographers. If you are familiar with these terms and concepts, skip ahead to the detailed sections on camera operation. As a matter of convenience (and easier reading), I will often refer to the Canon EOS 50D simply as the 50D or the EOS 50D.

Insider View: Few photographers, amateur or pro, know or understand every control on the camera. You don't need to know how to operate everything on your 50D in order to get great photos. Explore those features that work for you, try out some new ones, and forget whatever doesn't work for you. You can always come back to this book later to further develop your knowledge of 50D functions.

Reviewing the Differences Between Film and Digital

For photographers who have only shot digital, this section may seem like a curiosity. Still, there are enough people who have shot film or who talk about shooting film so that it is important to review some important differences between film and digital. Most photographers understand that digital cameras do some things quite differently from traditional film cameras. This next section will help you better understand digital photography—beginners may want to read it, others may skim or even skip it.

Film vs. the Sensor

Film and digital cameras expose pictures using virtually identical methods—a shutter and a lens opening (f/stop or aperture) control the light reaching the film or sensor. The exposure is determined by light metering systems based on the same technologies. The sensitivity standards for film and sensors are similar. These similarities exist because both film and digital cameras share the same function: to deliver the amount of light required by the sensitized medium (film or sensor) to create a picture you will like.

However, digital sensors react differently to light than film does. From dark areas (such as navy blue blazers, asphalt, and shadows) to midtones (blue sky and grass) to bright areas (such as white houses and sandy beaches), a digital sensor responds to the full range of light equally, or linearly. Film, however, responds linearly only to midtones (those blue skies and green fairways). Therefore, film blends tones

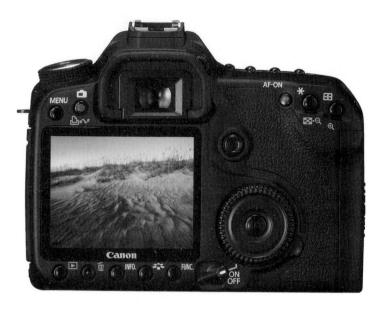

The 50D has a large, high-resolution LCD that makes it easy to carefully evaluate your images, allowing you to learn from mistakes and make better photographs.

very well in highlight areas, whereas digital sensors sometimes have trouble with the brightest tones. The 50D has a Highlight Tone Priority option to deal specifically with this challenge and make highlights look better. Digital technology typically responds to highlights the way slide film does, and to shadows as print film does.

The LCD Monitor

One of the major limitations of film is that you really don't know if your picture is a success until the film is developed. You have to wait to find out if the exposure was correct or if something happened to spoil the results (such as the blurring of a moving subject or stray reflections from flash). With digital single lens reflex, cameras, you can review your image on an LCD monitor—a screen found on the back of the

Be sure you have a memory card large enough that allows you to take any picture you want and capture unique shots as they appear.

camera—within seconds of taking the shot. While LCDs will not perfectly represent things like exposure and color, they provide a general idea of what has been recorded, so you can evaluate your pictures as soon as you have shot them. The 50D's new 3-inch, high-resolution LCD makes a big difference in what you can see on the LCD.

Memory Cards

Memory cards are necessary to store images captured by a digital camera. These removable cards affect photographic technique by giving you:

More photos—Memory cards come in a range of capacities that will determine how many photos you can record on a single card. But regardless of the particular capacity of your memory card, it is capable of holding the equivalent of many rolls of film.

- Removable photos—You can erase photos at any time from a memory card, removing the ones you don't want while opening space for additional photos, which will simplify the process of organizing your final set of images. Once images are transferred to your computer (or other storage medium such as an accessory hard drive or a high-quality DVD-R or CD-R), the card can be reused.
- Durability—Memory cards can be removed from the camera at any time (turn the camera off first and be sure no images are being still being recorded) without the risk of ruined pictures. CompactFlash cards (like those used in the 50D) are encased in solid plastic so they are unaffected if they are dropped or get wet. They can even be taken through the carry-on inspection machines at the airport without suffering damage.
- Small size—In the space taken up by just a couple of rolls of film, you can store or carry multiple memory

cards that will hold thousands of images.

Insider View: There are a few misunderstandings or "urban legends" about memory cards. It is amazingly difficult to damage a CompactFlash card. They are extremely durable and have been known to go through a washing machine without problems! You cannot "wear out" a memory card. You cannot hurt a memory card by erasing images from it, although it can get "confused" if you do too much of that without formatting the card. You should format your card regularly. You should also check a brand-new card immediately to be sure that it works properly. If a card fails, it will almost always fail immediately, and you don't want this to happen with your new card on your special trip. Try shooting some images with that new card and formatting it to be sure that it all works properly.

Exposure

There is still a misconception that you can perform magic with digital cameras. But your 50D will not allow you to escape the laws of physics: Too little light underexposes an image and too much overexposes an image—both are problems if you want optimum quality. What digital does allow,

however, is the ability to review your picture on the LCD monitor and reshoot if you have obviously exposed poorly. You can also use the histogram function to check exposures as you shoot. This feature, which is unique to digital photography, displays a graph that allows you to immediately determine the range of brightness levels within the image you have captured. In addition, the 50D offers a choice between the standard brightness histogram and the RGB histogram that EOS-1D series cameras offer (most photographers will find the standard, single display perfectly fine).

ISO Sensitivity

ISO is an international standard for quantifying film's sensitivity to light. Once an ISO number is assigned to a film, you can count on it having a standard sensitivity, or speed, regardless of the manufacturer. Low numbers, such as 50 or 100, represent a relatively low sensitivity, and films with these speeds are called slow films. Films with high numbers, such as 400 or above, are more sensitive and referred to as fast. ISO numbers are mathematically proportional to the sensitivity to light. As you double or halve the ISO number, you double or halve the film's sensitivity to light (i.e., 800 speed film is twice as sensitive to light as 400 speed and is half as sensitive to light as 1600 speed).

Technically, digital cameras do not have a true ISO. While the sensor has a specific sensitivity to light, its associated circuits change its relative sensitivity by boosting the signal from the chip. For practical purposes, however, a digital camera's ISO equivalent settings correspond to film, so that if you set a digital camera to ISO 400, you can expect a response to light that is similar to an ISO 400 film. So, with a digital camera, you change the sensitivity of the sensor using its electronics when you change the ISO setting. It is important to note, however, that because ISO in digital is not a standard, you may find a variation in exposure settings if you compare your 50D to a friend's Nikon or Olympus camera.

Insider View: Changing ISO picture-by-picture—on the fly, as needed—is easy with a digital camera. It is also a huge benefit for the photographer. For example, you could be indoors using an ISO setting of 1600 so you don't need flash, and then follow your subject outside into the blazing sun and change to ISO 100 to instantly deal with those conditions. The EOS 50D offers an extremely wide range of ISO settings from 100 to 12,800 (though its standard, or default range, is 100-3200). But I have to warn you that while these speeds sound incredible, there is a cost—you will get increased noise (graininess) in the images. The most practical range for highest quality with your 50D is 100-1600, although even 1600 may give many photographers more noise than they desire.

Noise

Noise in digital photography is the equivalent of grain in film photography. It appears as an irregular, sand-like texture that, if large, can be unsightly and, if small, is essentially invisible. (As with grain, this fine-patterned look is sometimes desirable for certain creative effects.) In digital cameras, noise occurs for several reasons: sensor noise (due to several factors, including heat from the electronics and optics), underexposure, digital artifacts (when digital technology cannot deal with fine tonalities such as sky gradations), and JPEG artifacts (caused by image compression). Of all of these, sensor noise is the most common.

Noise will emerge when you use high ISO speeds. On any digital camera, noise will be more obvious with underexposure and may also be increased with long exposures in low-light conditions. However, Canon has worked very hard to reduce noise in images produced by all of their cameras. There is advanced noise-reduction technology built into the 50D. Canon has managed to give the camera incredible image quality at high ISOs with low noise that simply wasn't possible in the past.

File Formats

A digital camera processes the continuous (or analog) image information from the sensor by converting it to digital data with an A/D converter (which is built into the camera). It converts this data into one of two different digital file formats, RAW or JPEG (and it will resize images, too, if desired).

RAW files are image files that include information about how the image was shot, but have minimal processing applied by the camera. They also contain the full 14-bit color information from the 50D, which is the maximum amount of data available from the sensor (it is a little confusing that the RAW file format actually uses a 16-bit file format, though the data from the sensor is 14-bit). The 50D's RAW file is based on the same advanced RAW format developed for the Canon EOS-1D Mark II, the CR2 file.

The EOS 50D can also produce two small RAW formats. They use the 14-bit color data, but give smaller, 3.8-megapixel and 7.1-megapixel RAW files instead of the normal 15-megapixel file. This significantly increases the number of RAW files that can be stored on a memory card.

JPEG is a standard format for image compression and is the most common file created by all digital cameras. This format is popular because it reduces the size of the file, allowing more pictures to fit on a memory card.

Insider View: I am not sure that the 3.8-megapixel size will really be a benefit to most photographers. Why would you want to shoot RAW at such a low megapixel count? Generally, RAW is for the utmost in image quality when you are processing the photo in the computer. The 3.8-megapixel size is not very large and will not allow you to do much with the photo. I think if you really need small file sizes instantly from the camera, perhaps for internet use as an example, you would be better off shooting with a small-image JPEG file (why bother with the added work of RAW?) or RAW plus JPEG, with the JPEG recorded at a small image size. However, the 7.1-megapixel size is big enough to create a high-quality, sizable image.

Shoot with the 50D's highest resolution in order to record the most detail possible from your camera.

Both RAW and JPEG files can give excellent results. The minimally processed data of a RAW file can be extremely helpful when faced with tough exposure situations or when you want the most from an image file when working in the computer, but the small file size of JPEG can be faster and easier to deal with. Also, JPEG will allow you to shoot approximately 90 shots at once (burst rate) with the 50D, which is great for sports or action, while RAW only allows 16 at once, plenty for most other subjects.

Digital Resolution

Resolution in the digital world is expressed in different ways depending on what part of the digital loop you are working in. For digital cameras, resolution indicates the number of individual pixels that are contained on the imaging sensor.

This is expressed in megapixels. Each pixel captures a portion of the total light falling on the sensor. And it is from these pixels that the image is created. Thus, a 15-megapixel camera has 15 million pixels covering the sensor. The 50D has pixel dimensions of 4752 x 3168, which give an effective pixel count of approximately 15.1 megapixels. (You will hear the term total pixels and effective pixels. The sensor's total pixels include some that are not usable for photography; the ones that are usable are the effective pixels.)

On the other hand, when it comes to inkjet printing, the usual rating of resolution is in dots-per-inch (dpi), which describes how many individual dots of ink are deposited per inch of paper area, a very different concept. It can be confusing; however it is important to remember that resolution in a digital image is totally different than a printer's resolution.

Dealing with Resolution: The 50D offers three different resolution settings between 3.7 and 15.1 megapixels. You don't always have to choose the camera's highest resolution, but generally, you maximize the photo's potential by doing so, allowing you to record the most detail possible with your camera.

The 50D has the potential of making great prints at 16 x 20 inches (40 x 50 cm) and more. When the image is shot at 15.1 megapixels, you actually have more than enough pixels for prints this size. Those extra pixels do allow you to crop your image to get rid of stuff you don't want and still be able to print a large photo. The higher the original shooting resolution, the larger the print you can make. Digital camera files generally enlarge very well in programs like Photoshop, especially if you recorded them in RAW format first (because there is more data in that format to work with), but you need the highest quantity of megapixels for the largest print sizes.

So why would you want to shoot with lower resolutions? Only if you have specific needs for that small size and you know the photos will never be needed for a large size. For example, if the photos are specifically for email or webpage use, you do not need to shoot with a high resolution in order

for the images to look good on screen. Or you wouldn't need maximum resolution if you are simply shooting to document a house's inventory or for use with a research project where the images will only be reviewed on screen.

Insider View: Realistically, given the low prices of today's memory cards, why would you buy a camera of this advanced level and handicap it to do less than its best by shooting at lower resolutions than the maximum? You can always reduce resolution in the computer, but you cannot recreate detail if you never captured the data to begin with. Keep in mind that you paid for the megapixels in your camera! The lower the resolution with which you choose to shoot, the less detail will be available for making enlargements.

The Color of Light

Anyone who has shot color film in a variety of lighting conditions can tell horror stories of awful color. Color reproduction is affected by how a film is "balanced" or matched to the color of the light. Our eyes adapt to the differences, but film does not.

With a digital camera, all of this changes. Digital cameras act more like our eyes and create images with fewer color problems than was ever possible with film. This is because color correction is managed by the white balance function, an internal setting built into all digital cameras. White balance has been a standard practice for videographers ever since portable color video cameras became available nearly 40 years ago. It allowed the cameras to use electronic circuits to neutralize whites and other neutral colors without using filters.

A digital camera works the same way. It can automatically check the light and calculate a setting to balance the light's color temperature. It can also be set to specific light conditions, or custom-set for mixed light and types of lighting that aren't included in the camera's presets. Thanks to this technology, filters are rarely necessary for color correction, making color casts and light-loss due to filter factors things of the past.

Don't be afraid to experiment! There is no cost to taking pictures with your 50D.

Cost of Shooting

Once you've paid for your camera, lens(es), and memory card, there is virtually no cost to shooting a large number of photos, since the memory card is reusable. This is hugely liberating for you as a photographer. Now you can try new ways of shooting, experiment with creative angles never attempted before, and so much more.

Features and Functions

I have to be honest—I have loved seeing the evolution of digital photography. I believe it has brought new levels of image-making capabilities for everyone. With each new generation of cameras, I say, "Wow!" Cameras are amazing pieces of engineering, and manufacturers have brought them to a level beyond what they offered in the film days. In fact, your Canon EOS 50D is capable of results far better than what was possible with 35mm.

Insider View: I know there are some folks who dispute that today's digital cameras yield better photo results than film, but they are people who most likely have never made prints from the image files. They come up with numbers through arbitrary math exercises that attempt to compare theoretical megapixels for film resolution to actual digital resolution. This type of "spreadsheet" comparison fails to look at real photographs. Film is an old technology; digital is a new technology. Numbers don't tell the story any more than saying a fluorescent light bulb has to have the same wattage as an incandescent in order to give the same brightness—they're different technologies and just are not related proportionately in that way.

With its high resolution sensor, ability to record 14-bit color depth files, advanced DIGIC 4 image processor, and other features, the 50D is capable of creating images even better than those possible with 35mm film.

This book will give you an idea of what is possible with the many features on the EOS 50D, as well as help you best utilize those that are most important to you. There is no need to feel guilty if you don't use every option packed into this camera. However, if you want to try any of them, just do it! That is what's cool about digital. You don't have to remember every little feature—you can just try it and see what it does if you don't remember specifics! You won't waste film, so you can experiment with every feature on your 50D and actually see how each functions by immediately checking the LCD review. This is a quick and sure way of learning to use your camera, and allows you to choose those functions that are most useful to you.

Just like the EOS 40D and 5D Mark II cameras, the EOS 50D offers a high degree of technological sophistication at a moderate price. Once again, Canon continues to offer more features at the same or lower price! With a sensor that contains 15.1 megapixels, the 50D shoots up to 90 frames at a maximum speed of 6.3 frames per second (fps) when using a UDMA CF card. Like the 40D, it offers one of the quickest start-ups of any D-SLR, fast writing speeds to the memory card, interchangeable viewfinder screens, and other controls that bring it close to the performance of recent top pro cameras, such as the EOS-1D Mark III.

Built with a stainless steel chassis, the camera is housed in a well-sealed magnesium-alloy body. While these materials are more expensive than a number of others, they create a construction that is lightweight yet strong. This camera is very durable. The mirror box is made of an extremely high-quality, high-tech plastic. Canon slightly redesigned the body of the 40D around the flash head and lens mount to make the camera "suggest Canon's upper-range models" and continues that look with the 50D. Just like the 40D, the 50D is well sealed for superior dust and water resistance. The exterior of the camera is finished with a high-grade, black satin paint with a leather finish.

As with all Canon EOS cameras, the 50D uses the Canon EF lens mount and accepts all standard Canon EF lenses. It addition, the camera accepts compact EF-S lenses, which are made

The 50's 3-inch LCD monitor offers you the freedom to try out camera settings and see the results immediately. With a static subject, this is especially useful because if you didn't get the effect you wanted, you can simply shoot it again!

for small-format sensors and can only be used on cameras designed specifically to accept them. (Important: EF-S lenses cannot be used on full-frame cameras or on older APS-C cameras such as the EOS 10D. The lenses sit deeper in the camera's body compared to an EF lens and may damage the mirror of a camera for which they are not intended, plus they do not cover the image area of sensors larger than APS-C size.)

The basic internal construction, as well as the way in which major parts are used in the camera, is pretty much the same as the EOS 40D, including the professional quality shutter, which is rated to 100,000 cycles. In addition, there are some important new details of construction not found on the 40D, including the high-resolution 920,000 pixel 3.0-inch LCD, a DIGIC 4 internal processor, and HDTV support with HDMI output.

Canon EOS50D - Front View

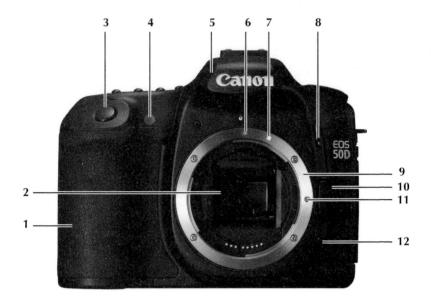

- 1. Grip, battery chamber
- 2. Mirror
- 3. Shutter button
- 4. Red-eye reduction / Self-timer lamp
- 5. Built-in Speedlite
- 6. EF lens-mount index
- 7. EF-S lens-mount index

- 8. \$ Flash button
- 9. Lens mount
- 10. Lens-release button
- 11. Lens lock pin
- 12. Depth-of-Field Preview button
- 13. Electronic contacts

Canon EOS50D - Back View

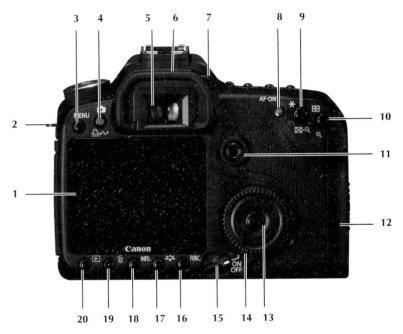

- 1. LCD monitor
- 2. Strap eyelet
- 3. MENU button
- 5. Viewfinder eyepiece
- 6. Eyecup
- 7. Diopter adjuster
- 8. AF-ON button
- 9. ★ / ♣ · Q : AE lock / Index / Zoom out button
- 10. ☐ / ⊕ : AF point select

- 1. Handar Multi-controller
- 12. Memory card slot cover
- 13. F button
- 14. O Quick Control Dial
- Power / Quick Control Dial switch
- 16. FUNC. button
- 17. Picture Style select button
- 18. INFO. / Trimming button
- 19. Delete button
- 20. Playback button

Canon EOS50D - Top View

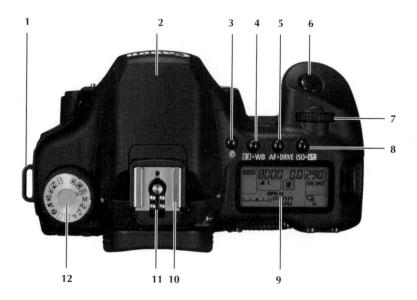

- 1. Strap eyelet
- 2. Built-in flash
- 3. LCD panel illuminate button
- / White balance button
- 5. AF DRIVE: AF mode / Drive mode select button
- 6. Shutter button

- Main Dial 7.
- 8. ISO-52: ISO set / Flash exposure compensation button
- 9. LCD panel
- 10. Hot shoe / Accessory shoe 11. Flash-sync contacts
- 12. Mode Dial

Canon EOS50D - Side View

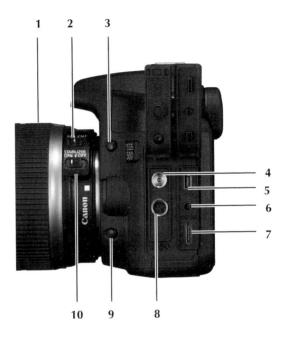

- 1. Lens
- 2. AF/MF switch
- 3. 4 Flash button
- 4. PC terminal
- 5. Digital (USB) terminal
- 6. Video OUT terminal

- 7. HDMI mini OUT terminal
- 8. Remote terminal
- 9. Depth-of-Field Preview button
- 10. Image Stabilization (IS) switch

Overview of Features

- Canon-designed 15.1 megapixel CMOS sensor, smallformat, APS size
- 14-bit A/D conversion (analog/digital conversion from the sensor signal to a digital file) yields finer gradation, more colors than before.
- DIGIC 4 with multi-channel reading for faster processing and writing as well as improved color and noise processing capabilities
- Advanced AF-sensor with 9 cross-type AF points
- Shoots 6.3 fps up to 60 frames consecutively (burst rate) at maximum JPEG resolution with standard CF cards, 90 frames with UDMA CF cards.
- Shoots 6.3 fps up to 16 frames continuous in RAW (up to 10 frames using RAW + JPEG).
- Changeable High-speed/Low-speed continuous shooting option
- AF-start button
- Programmable Function button
- Live View function (silent shooting mode provided) lets you view image in real time through your LCD monitor.
- Magnification in Live-View for improved focusing
- Live View start button
- Live View face detection
- Bright, sharp viewfinder optics and large pentaprism yield 0.95x magnification, 26.4° angle of view, and 22mm eyepoint.
- Viewfinder with 95% coverage
- Interchangeable focusing screens
- 3.0-inch (7.6 cm) Clear View high-definition LCD monitor with 920,000 pixels
- New Quick Control screen that shows control settings on the LCD monitor
- 35-zone full-aperture metering
- Spot metering, same as EOS-1 Series and EOS 5D
- Auto ISO in Creative Zone modes
- Standard ISO 100-3200; expanded capability of 6400 and 12,800
- New Auto Lighting Optimizer function in all Basic zones

- New lens peripheral illumination correction
- High degree of customization with 25 Custom Functions offering 72 settings, My Menu, and Flash Custom Functions
- New Creative Auto (CA) shooting mode designed for beginners who want to go beyond Full Auto mode
- Advanced PictBridge features preview of printing effects and tilt correction (±10° in 0.5° increments).
- Highlight Tone Priority function
- Self-cleaning sensor unit with new fluorine coating to minimize dust
- Dust Delete Data obtained and appended to image.
- Upgraded dust and weather seals
- Self-timer 10 seconds or 2 seconds
- USB 2.0 interface
- HDMI interface
- Start-up time of 0.15 seconds
- High-speed shutter up to 1/8000 second with standard flash sync up to 1/250 second
- Built-in Multi-controller for easy access to AF points and a "one-stop" button for the menus
- Fully compatible with entire EOS system of lenses, flash, and other accessories
- Power-saving design promotes longer battery life.

Camera Controls

The EOS 50D uses icons, buttons, and dials common to all Canon cameras, though if you are used to early models of this series, some of the back buttons are in new locations due to the size of the LCD. Specific buttons will be explained, along with the features they control. The 50D often uses two control dials to manage many of the most common and important functions.

Main Dial

Positioned behind the shutter button on the top right of the camera, this allows you to use your shooting finger to set things like exposure. The Main Dial works alone when setting shutter speed and aperture. For a number of other adjustments, such as metering mode, ISO settings, and AF mode, it works in conjunction with buttons that are either pressed and released or are held down while the dial is turned.

Quick Control Dial

This large, thumb-controlled dial on the back of the camera is a long-time Canon control found on most of their D-SLRs. Probably its most important uses are for adjusting exposure compensation and for selecting menu items in the LCD monitor. It activates for six seconds when an associated operational button is pressed. However, the three-way power switch, located below and to the left of this dial, controls functionality. When the switch is in the ON position, the

can be used to select the AF point and menu items, or to set white balance, ISO, or flash exposure compensation. With the power switch set to the angled line (top position, , the has two additional functions: (1) It can be

used to set exposure compensation, and (2) to select the

aperture in Manual Exposure mode.

ۥ3 Multi-Controller

This control sits just above the Quick Control Dial. It is like a mini-joystick controlled by your thumb and is used for several adjustments that need multi-directional movement. being especially useful for AF-point selection. It also works

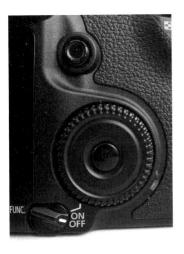

The Multi-controller (top) and Quick Control Dial (bottom) are key controls for your 50D.

nicely for the camera's menus if you like to just use one control. You can move from menu to menu (sideways movement), scroll through menu items (up and down), and select or set adjustments (push).

Insider View: The different uses of these three controls (, , , and , and ,) sometimes seem like a lot to remember. I find it confusing on occasion trying to stay on top of which dial sets what function or item, especially because I don't constantly adjust certain settings and have to remember what dial to use when I do. For example, I don't change ISO very often, so I often forget how to immediately make changes. On the other hand, since I use exposure compensation frequently, I have no problem remembering the Quick Control Dial controls it. For most controls, the Main Dial and the Quick Control Dial are the ones used, so you usually have a 50% chance of using the correct one! But if you're like me, you'll end up missing the right one 90% of the time! That's no big deal, just reverse the setting you didn't mean to change, and then use the other dial.

Shutter Button

The 50D features a soft-touch electromagnetic shutter release. Partially depressing the shutter button activates certain camera functions, such as autoexposure and autofocus (AF).

Insider View: How fast a camera reacts to a scene is influenced by how quickly it can find the subject on which to focus, especially if shooting **ONE SHOT** AF. For stationary subjects, there is minimal speed advantage in pushing the button halfway before exposure because this camera is so fast. That's not true for moving subjects, though. For them, start autofocusing early, so the camera and lens have time to find your subject. You can also use the AF-ON (AF-start) button on the back of the camera to start autofocus.

Camera Activation

Three-Position Power Switch

The EOS 50D has a three-position power switch found on the back of the camera below the LCD monitor. The three positions are: OFF, ON, and a special ON setting. This additional ON position is marked by the angled line described earlier, and is used to activate both the camera and the Quick Control Dial for exposure compensation and aperture selection in Manual Exposure (M) mode.

Sensor Cleaning

When you turn the camera on and off, the self-cleaning sensor unit is activated to automatically shake dust from a filter in front of the sensor. This filter is coated with fluorine to minimize the amount of dust it attracts. You will see the symbol for the sensor appear in the LCD when you turn the camera on. Though this keeps dust from building on your sensor, it also slows the camera slightly from being ready for use. If you need your camera to activate faster, you can turn this function off in Set-up 2 menu \$\mathbb{\psi}\$: See pages 59-60 for more details.

Auto Power Off

Auto power off is an important control on most digital cameras, but is one that photographers often do not alter. You should find this control and consider what you really need from it. The 50D's *Auto power off* selection is in Set-up 1 menu *\mathbb{\text{r}}\ and can be used to shut off the power after a period of idleness, spanning from one to 30 minutes. If you do not want the camera to turn itself off, set this feature to *Off* and the camera will remain on as long as the power switch is activated.

To access the *Auto power off* function, press the button (on back of the camera above the top left corner of LCD monitor) and scroll to Set-up 1 menu wings the Main Dial . When wis highlighted (color code for all Set-up Menus is yellow), use the Quick Control Dial to select *Auto power off*, the first option in this menu. Press will located in the middle of the Quick Control Dial, and you will see a number of choices ranging from one minute to 30 minutes, plus the *Off* option that prevents the camera from turning off automatically. Use the to scroll, and then press will to select your desired duration.

Insider View: Auto power off may be helpful to minimize battery use, but I find the one-minute default setting to be frustrating. Too often, I try to take a picture and find that the camera has shut itself off. For example, you might be shooting a soccer match and the action is at the other end of the field for a short time. If *Auto power off* is set to 1 min., the camera will likely be off as the players move toward you, meaning nothing will happen when you try to shoot. You may miss the important photo! Depending on your shooting needs, change the setting to at least 2 min., but 4 min. or 8 min. may actually be better, so that the camera stays on when you need it to be on.

Resetting Controls

With the many controls built into the 50D, it is possible to set so many combinations that at some point you may decide to reset them all. You can restore the camera to its original default settings by going to *Clear settings* in the Setup 3 menu **\Pi**: Be cautious about doing this, though, because it really does reset ALL of your controls.

The Viewfinder

The 40D had a completely new design for its viewfinder compared to the 30D, and the 50D keeps this design. The pentaprism that directs the image to the eyepiece is enlarged and optimized, plus the eyepiece itself is enlarged. This gives the viewfinder a bigger look with more consistent brightness from corner to corner (minimizing vignetting or darkening of corners). The viewfinder shows approximately 95% of the actual image area captured by the sensor (you get 100% with Live View on the LCD). The eyepoint is 22 millimeters, which is good for people with glasses.

The viewfinder provides magnification at 0.95x and includes a display of superimposed information that is easy to see in all conditions. The display includes a great deal of data about camera settings and functions, though not all these numbers are available at once. The camera's nine autofocus points appear on the focusing screen, and the bottom of the screen displays information for exposure, flash, white balance correction, maximum burst, CF card, and AF/MF (auto/manual focus) confirmation (a circle appears on the far right when the camera is in focus). New data first displayed in the 40D and now the 50D are ISO setting, an alert symbol to indicate the camera has been set for black-and-white, and a 2-digit display (instead of one) for maximum possible burst. Depth of field can be previewed through the viewfinder by using the Depth-of-Field Preview button near the lens on the lower left front of the camera.

The focusing screens were big news for the 40D because they were the first interchangeable screens for a camera of this type, and the 50D continues this feature. The Ef-A Standard Precision Matte is very similar to the non-interchangeable, precision matte focusing screen in older Canon cameras, and it is now produced by a molding process first developed for the EOS-1D Mark III that allows it to offer better performance. This screen uses special microlenses to make manual focusing easier and increase viewfinder brightness. The Ef-D Precision Matte with Grid adds a grid to the screen that can be helpful in lining up critical horizontal or vertical lines in a photograph. The Ef-S Super-Precision screen makes it easier to find the "sweet spot" of focus when using very fast lenses or in difficult, manual focus conditions.

Insider View: Most photographers are going to be fine with the standard viewfinder screen, which is probably good, because changing screens can be tricky and may let dust seep into the camera. But it is nice to have options for photographers who need them.

The mirror lifts for the exposure, then rapidly returns to keep viewing blackout to a very short period. The mirror is also damped so that mirror bounce and vibration are essentially eliminated.

Viewfinder Adjustment

The 50D's viewfinder features a built-in diopter adjustment (a supplementary lens that allows for sharper viewing). The diopter will help you get a sharp view of the focusing screen so you can be sure you are getting the correct sharpness as you shoot. For this to work properly, you need to adjust the diopter for your eye. The adjustment knob is just above the eyecup, slightly to the right. Fine-tune the diopter setting by looking through the viewfinder at the AF points or other displayed items, such as exposure settings (don't try to focus on a real scene). Then rotate the dioptric adjustment knob until the display appears sharp. You should not look at the subject that the camera is focused on, but at the actual points on the viewfinder screen.

Viewfinder

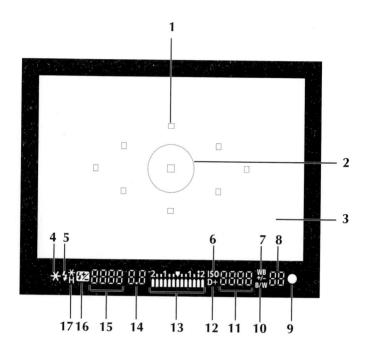

- 1. AF points
- 2. Spot-metering circle
- 3. Focusing screen
- 4. ★ : AE lock / AEB in progress
- 5. 4 : Flash ready, Improper FE lock warning
- 6. ISO speed
- 7. White balance correction
- 8. Maximum burst
- 9. Focus confirmation
- 10. Black-and-white shooting
- 11. ISO sensitivity
- 12. Highlight tone priority

- 13. Exposure / Exposure compensation / Flash exposure compensation / AEB scale
- 14. Aperture
- Shutter speed / 4 buSY
 Flash recycling / (FEL) FE
 lock / buSY, Card full (FuLL
 CF) / No card (no CF) / Card
 error (Err CF) warnings
- 16. 62 : Flash exposure compensation

progress

Insider View: Some Canon literature claims you can use this adjustment to see through the camera comfortably, with or without eyeglasses, though I have found that the correction isn't really strong enough for most people who wear glasses regularly (like me).

The LCD Monitor

The LCD monitor is probably the one feature of digital cameras that has most changed how we photograph. The 3.0-inch, high-resolution LCD monitor found on the back of the 50D is absolutely stunning. The first time I saw this, it reminded me of looking at high quality slides from the film days. With 920,000 pixels (four times the resolution of the 40D's LCD), a wide viewing angle of 140 degrees, and improved visibility, this screen is extremely useful for evaluating images and using menus. In fact, the larger, sharper monitor means the menus are easier to read, too.

Insider View: The 3.0-inch LCD on the 50D is truly beautiful. I knew the small monitors that used to be common quite well, and the 2.5-inch monitor on the 30D was a welcome improvement at the time. The extra half inch of a 3-inch monitor really made a difference with the 40D; and now the increased resolution plus better color gamut and brightness give a huge boost to the 50D's monitor. No monitor is yet ideal for viewing in bright sun, but this one is very good outdoors.

In addition, you can now set the camera to display the Quick Control screen in the LCD monitor, which allows you to directly set such things like shutter speed, f/stop, white balance, exposure compensation, and so forth. Use the INFO button below the monitor to cycle through different sets of data display. The Quick Control screen gives clear information for beginners as well as instant access to frequently used settings. The bright screen makes it easy to set camera controls in low light or when the camera is high on a tripod, situations where it may be difficult to see this information usually found in the LCD panel on the right top of the camera.

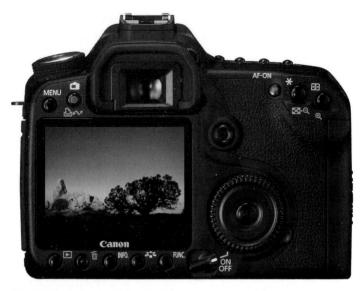

The LCD offers you a quick view of your image so you can see how well your photograph was recorded.

The LCD monitor in the 50D can also display a photo file's histogram (see pages 146-149—the 50D can show both luminance and RGB histograms). The histogram can be a great aid to getting better exposure.

Insider View: The 3-inch monitor of the 40D was a really big deal, which you already know if you have been shooting with a digital SLR for a while. But this new high-resolution monitor for the 50D truly gives you a new connection to your camera. Any LCD monitor gives you the ability to see the recorded picture combined with an exposure evaluation (the histogram). That means you can identify under- and overexposures, color challenges, lighting problems, flash setup, and compositional issues while you are still in the field with your subject. You can deal with those issues on the spot!

The 50D can also rotate images in the LCD monitor. The setting for Auto rotate is found in Set-up Menu 1 . This will make vertical images smaller in the monitor, but they will display with a vertical orientation without holding the camera in the vertical position (and they display vertically when they go into the computer as long as the software recognizes that command in the EXIF file data). Turning off the Auto rotate feature keeps the image as big as possible, but a vertical image appears sideways in the LCD. A third option lets you automatically rotate images when they are opened in the computer, but not when viewed on the LCD.

Insider View: This last option is one that I recommend to all of my workshop students. Turn off the 50D's in-camera Auto rotate because otherwise you are not getting the most from this beautiful LCD. A vertically rotated image inside the horizontal LCD makes the image considerably smaller and harder to see. Plus, it is a real problem when the camera is mounted vertically on a tripod—the auto-rotated photo is sideways!

You can magnify an image in the monitor up to 10x during Playback by pressing the magnify button \bigcirc . The enlarged photo is scrollable with the Multi-controller, which allows you to inspect all portions of the picture. But rather than pressing the minus magnifier repeatedly to get back to the whole image, just press the Playback button once—that takes you instantly to a full view. The 50D uses the Main Dial in Playback mode to skip over images (in increments of 1, 10, or 100) or to search by shooting date. Use the second Playback menu \blacksquare and select Image jump with \square to choose the desired jump increment when using the Main Dial.

Live View Function

Canon introduced Live View to their D-SLRs with the EOS-1D Mark III and it was included in the 40D. It is much improved in the 50D. This technology displays a live image directly from the sensor on the LCD monitor, and is available for use in the 50D's Creative Shooting modes (P, Av, Tv, M and A-DEP). So you now have two choices for viewing

your scene before photographing it: (1) Through the traditional viewfinder (which is bright and clear on the 50D), or (2) on the LCD monitor through the sensor (which is a direct view, though darker and affected by bright light). A big improvement to the 50D's Live View is the high-resolution LCD, which really does help a lot, plus you can now go directly to menus while in Live View, which you could not do with the 40D.

Live View offers a number of advantages. For one, you can see what the white balance looks like. You can also get an idea of the exposure, you can see 100% of the frame, you can shoot more quietly, and you can focus very precisely. There are, however, some disadvantages: It is slower than using the viewfinder, it is hard to use in bright light, AF is not as efficient as when you use the viewfinder, it consumes significantly more battery power, and there can be internal heat and noise issues.

Live View is now directly accessible via the Live View button at the top left of the back of the 50D. Press the button and Live View is activated. How Live View works with autofocus and other functions is controlled at the bottom of Set-up Menu 2 **?**: , where you can also disable Live View.

Insider View: Live View is the wave of the future. Olympus was first to incorporate real-time viewing through the LCD monitor of a D-SLR, and now most manufacturers are working on such cameras. This makes a D-SLR act a bit like a point-and-shoot digital camera; consequently, some photographers belittle this feature. However, I believe this is a valuable tool. The camera acts like a miniature view camera, allowing you to better see the whole photograph, not simply sight on a subject (which is how the viewfinder works). Live View is also more convenient to show what the lens is seeing when the camera is above or below eye level, and I also find it is great for close-up work.

There are several function settings you can choose to use while in Live View. For one thing, you are able to turn a grid display on or off (this can be really helpful when shooting architecture or landscapes with a horizon because the grid can make sure that vertical and horizontal lines look straight). You can set *Metering timer* to select the length of time that a metered exposure setting is kept, and you can also opt to select or disable different Silent shooting modes.

The Silent shooting modes, Mode 1 and Mode 2, are pretty neat. Both are quieter than shooting the standard way because there is no sound from the mirror popping up and back to take the picture. For Mode 2, the 50D uses a partial electronic shutter (meaning the sensor is used to control the shutter speed). This allows you to take a picture with no sound at all as long as you continue to hold the shutter release. When you stop pressing the release, camera operation will resume and it will make a small noise to get ready for the next shot.

A very useful Live View function setting is new to the 50D, Exposure Simulation (called "Expo. simulation" in the menu). This setting gives you a direct feeling for the exposure by making the monitor look dark for underexposure and light for overexposure. If this is disabled, the monitor will have a brightness that stays consistent for focusing and viewing, regardless of the exposure setting. Be careful of this setting as it can mislead you into thinking your photo looks better than it does.

Autofocus (AF) while in Live View has been improved with the 50D. The 40D had only one AF mode, Quick Mode, in which the camera stopped the Live Mode view while it autofocused. In the 50D, Quick Mode has been improved so that Live Mode instantly reappears after focusing. In addition, there are two new AF modes. First, the image sensor is used to autofocus while Live Mode continues. This is not as good in AF using the AF sensor in the viewfinder, but it does work. Second, there is now a face detection feature where the camera recognizes and focuses on faces in the scene as imaged by Live View.

LCD Panel

- 1. Image quality
- Shutter speed, buSY / (buSY) Built-in flash recycling
- 3. Beeper
- 4. Metering mode
- 5. Aperture
- 6. Shots remaining during WB bracketing / on card, Self-timer countdown, Bulb exposure time
- 7. AF point selection, Card full (FuLL CF) / No card (no CF) / Card error (Err CF) warnings, Error code (Err), Cleaning sensor (CLEAn)
- 8. White balance correction
- 9. AF mode
- 10. AEB

- 11. Drive mode: Self-timer
- Drive mode: single or continuous shooting
- 13. ISO sensitivity
- 14. Black-and-white shooting
- 15. Highlight tone priority
- 16. Battery power indicator
- 17. Exposure / Exposure compensation / Flash exposure compensation / AEB scale, Card writing status
- 18. Flash exposure compensation
- 19. White balance

The LCD Panel

Not to be confused with the LCD monitor, the small black and gray panel that sits to the right of the viewfinder on the top of the 50D is designed to display information about camera settings including exposure, white balance, drive settings, metering type, and much more. It can be illuminated in dark conditions by pressing the LCD panel illumination button 3, located just in front and to the left of the panel.

Power

The EOS 50D is powered by a BP-511A lithium rechargeable battery pack, although the BP-511, BP-512, or BP-514 battery packs can also be used. The BP-511A that comes with the camera holds the most power (and significantly so). In addition, the 50D has a battery charge display with four icons that designate increments of residual power so you can better judge a battery's remaining charge. One thing to keep in mind is that this charge display is not like a gas gauge. It will fluctuate depending on the drain on the battery. For example, you might find it low when using Live View, yet if you turn the camera off for a short time, then turn it back on without Live View, it may look like it "gained" power.

The camera is designed for efficient use of battery power. For example, using the LCD monitor is extremely important for digital photographers, yet that consumes significant amounts of power. So Canon engineers have incorporated a microcomputer power-management system that enables you to get the most shots possible from your battery. However, power consumption is also dependent upon how long other features, such as flash, autofocus, Live View, and image stabilization are used. The more the camera is active, the shorter the battery life. Never travel without backup batteries (and it is always a good idea to shut the camera off if you are not using it).

Insider View: I travel with three batteries. This allows me to carry two while one is being charged. Then that night I can rotate batteries, grabbing the battery from the charger for the next day, placing one of my depleted batteries in the charger overnight, and leaving a final battery on charge when I go off to shoot. Batteries last a long time in the EOS 50D. I have shot entire days without changing the battery, but it is good to know I always have a backup.

Low and high temperatures will reduce the number of shots that can come from your battery. The BP-511A is rated at 8.4 volts and it takes about 100 minutes to fully charge on the CG-580 charger that is included with the camera. It can also be charged in the CB-5L charger used with older cameras, but that charger has a separate cord. The CG-580 is a one-piece compact unit with built-in, foldout power prongs.

Insider View: A little comment on heat and cold—cold is not a big problem with digital SLRs, other than the potential for condensation (never take a cold camera directly into a warm room, for example; keep it in a bag until it warms up). A bigger problem is loss of battery power. Cold temperatures will give you much less time with a given charge, although if you warm up a battery, you will find you get back some power. Hot temperatures and direct sunlight (which will heat up a black camera) can damage your camera. Don't leave it sitting in your car on a warm or sunny day!

Battery Grip BG-E2N attaches to the bottom of the camera and can be used with two BP-511A or equivalent batteries, offering twice the number of shots. The grip also has an adapter to allow six AA-size batteries to be used. That can be really convenient if you are caught in the field with no charged battery—you can almost always buy AA batteries. Many photographers also like this grip because it makes vertical shooting easier, since it includes a vertical-grip shutter button, AE Lock button, and AF-point selection button. The AC Adapter Kit (ACK-E2) is useful for those who need the camera to remain continuously powered (i.e., for scientific lab work). Another power adapter, the CA-PS400, charges

Be sure you have enough batteries. It is very disappointing to be in a great location with perfect lighting and have your camera fail due to loss of power.

two batteries simultaneously, and with the DR-400 DC coupler cord, can be used to supply AC power as well.

Date/Time

To set time and date, first go into **\Psi**: Scroll down using the Quick Control Dial to select Date/Time, then press **\sigma**: Continue using the Quick Control Dial and to select and confirm the current time and date.

Insider View: I believe that setting the correct date and time is really important. More than once I have checked the time on a photograph so I can better identify something in it. Also, I will use the date and time to sort certain pictures. A number of cataloging and image-management software programs use the date/time metadata that is recorded

with the image so you can easily sort and edit photos. One thing that is important, however, is that you reset your time when you travel to a new time zone or you will get odd times for your photos!

A special lithium battery at the left side of the battery compartment powers the date and time clock. Canon says the life is about 10 years—I have yet to change one from an older model. If need be, it is easy to change: Simply slide the battery holder out and put in a new battery.

The Sensor and Processor

Canon has a well-respected reputation for making their own CMOS sensors that record images with very low noise. The EOS 50D uses a highly engineered 15.1 megapixel sensor (4752 x 3168 pixels) with 14-bit color depth. It can create images that will make superb, film-quality 16 x 24 inch prints (406 x 610 mm), as well as quality magazine images that can be reproduced across two pages.

Insider View: As I mentioned earlier, there are still a few folks who are convinced that the quality of digital images will never match that of film. Some of these people use bogus calculations to mathematically compare the two formats, without looking at actual results. I can tell you from experience, having seen many thousands of the best nature photos in the world in my role as long-time editor of Outdoor Photographer magazine, that the sensor used in the 50D offers stunning results that surpass 35mm film in every way.

The 50D's APS-sized CMOS sensor is the same size as that used for the 40D, 30D, 20D, and Digital Rebel models (it is named APS-sized, or APS-C, because it is the size of film used in the old Advanced Photo System—22.5 mm x 15 mm). Because this sensor covers a smaller area than a 35mm film frame, it is considered a small-format sensor and records a narrower field of view than a 35mm film camera. To help photographers who are used to working with 35mm

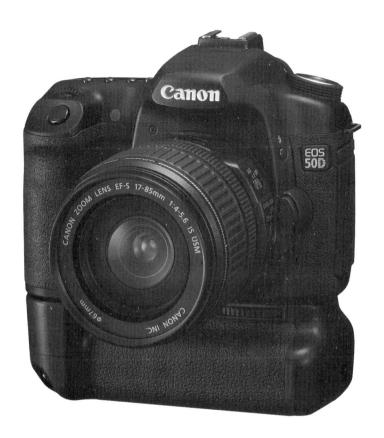

The 50D includes a highly-engineered, 15.1 megapixel CMOS sensor, offering high-quality image capture.

SLRs visualize the narrower field of view, a magnification factor of 1.6 is sometimes applied when describing the lens' focal length. Thus, on the 50D, a 100mm lens will have a field of view similar to that of a 160mm lens on a 35mm camera. Remember, the focal length doesn't change, just the view captured by the 50D's sensor.

The 50D's APS-C sized sensor gives a 1.6x magnification factor for lenses compared to focal lengths used for 35mm film.

Insider View: This magnification factor is great for telephoto use. It means you can get more magnification of your subject within the image area with a smaller, less expensive lens. Wildlife photographers, for example, can travel with lighter, more portable lenses. But it does create a challenge at the wide-angle end, where a 28mm focal length now acts like a 45mm lens. But the 50D accepts the well-designed Canon EF-S lenses, which are specially engineered for this format of sensor. They include a highly rated 10-22mm zoom that offers an equivalent 16-35mm focal length.

Though small-format, the sensor in the 50D uses some advanced sensor technology to add extra pixels into that APS-C format without losing image quality (image quality can be affected when pixels get too small). It adds nearly 50% more pixels in the same space compared to the 40D, so obviously each pixel is smaller. Smaller pixels can mean more noise and less sensitivity, but the 50D's sensor uses new technologies for CMOS fabrication and microlens design. Its 15.1 megapixels offer a higher ISO range than the 40D.

Canon did this by using a new photodiode construction (the photodiode is the smallest part of a sensor—the "pixel") and gapless microlenses to get the most out of the sensor even with increased pixels. In addition, there is a new three-layer, high-performance, low-pass filter with infrared block-

Inside the 50D is amazing computing power that rivals that used in laptops just a few short years ago.

ing over the sensor that increases the performance of the sensor. And Canon has a new version of their well-respected DIGIC processor, the DIGIC 4, to help control noise and gain better color.

Canon uses the company's latest image processor, the DIGIC 4. This in-camera processor (essentially a miniature computer dedicated to the camera) continues the its predecessor's reputation for image detail and natural colors, while

providing faster signal processing speed. Especially important is the color depth—the analog output signal from the sensor (all sensors are analog) is converted into a digital signal with 14 bits (16,384 colors) per channel instead of the previous standard for digital cameras of 12 bits (4,096 colors)—a 4x increase in data per RGB channel (or 12x over all, considering each of the three channels). This gives the potential for much finer color and tonal gradation.

With RAW files recorded at 14 bits, you can use any RAW converter to work in a 16-bit space (16-bit is the standard working file bit-depth). This yields the maximum range of colors possible from 14-bit processing. Also, because images recorded in JPEG (only 8 bits per color) are generated from 14-bit RAW data in camera, JPEG images are improved as well. Even challenging images such as subjects with high contrast can be controlled, yielding smooth tone rendition from highlights to shadows.

Insider View: You will hear some folks say you should never record using JPEG's 8-bit files because more bit depth is always better. That's a little misleading because, in the case of the 50D, the JPEG files are intelligently processed by the camera from the 14-bit data. High bit depth can be especially important with critical processing when you plan to print at a large size.

The on-chip RGB primary color filter uses a standard Bayer pattern over the sensor elements. This is an alternating arrangement of color with 50% green, 25% red, and 25% blue; full color is interpolated from this data. In addition, an infrared cut-off, low-pass filter is located in front of the sensor. This three-layer filter is designed to prevent the false colors and the wavy or rippled look of surfaces (moiré pattern) that can occur when photographing small, patterned areas with high-resolution digital cameras.

Cleaning the Sensor

any time by selecting Clean now.

The EOS 50D includes a self-cleaning mechanism that goes a long way toward keep dust and dirt from your photos. This unit shakes a layer in front of the sensor (called the low-pass filter) to knock the dust off. The layer is coated with fluorine, which gives it some dust-repelling properties. This cleaning occurs automatically by default when the camera is turned on and off. The control is accessed from Set-up Menu 2
•• , via the Sensor cleaning option. Then, by scrolling to Auto Cleaning, you can choose Enable (recommended) or Disable as the default. And, if you find dust on your images, you can also tell the camera to perform a self-cleaning at

Insider View: There is an easy way to check for dust on the sensor. Take a picture of a blank surface, such as the sky. Look for little black blobs on the picture—these are dust specks. If you see these blemishes, try the *Clean now* feature (you can also turn the camera on and off to start the automatic dust removal if engaged), and recheck. If you still see dust, you will have to clean the sensor manually.

When dust is a continuing problem, you can clean the filter in front of the sensor (referred to as cleaning the sensor) manually, but you must do this carefully and gently, indoors and out of the wind. Your battery must be fully charged so it doesn't fail during cleaning (or you can use the AC adapter). The sensor is very fragile and sensitive, so stay away from it. If the gentle cleaning described below doesn't work, you should send the camera to a Canon Service Center for a thorough cleaning.

Note: Though this is described as cleaning the sensor, you actually do not touch the sensor. You are cleaning the protective glass cover over the sensor. Though the cover is not as delicate as the sensor, it is not made for rough handling.

To clean the sensor manually, scroll and select Sensor cleaning in the from menu, then scroll to Clean manually and press follow the instructions that appear on the screen. When you select OK, the LCD monitor turns off, the mirror locks up, and the shutter opens and "CLEAn" will blink on the LCD panel. Take the lens off. Then, holding the camera face down (very important), use a rubber-bulb blower (such as Giottos Rocket Blower) to gently blow any dust or other debris off the bottom of the lens opening first, then off the sensor. Do not use brushes or compressed air because these can damage the sensor's protective surface. Be careful not to touch anything inside the camera with the blower. Turn the camera off when done. The mirror and shutter will return to normal. Put the lens back on.

Caution: Never leave a D-SLR without a body cap for any length of time—that is a sure way to get dust inside. Lenses should be kept clean and capped when not in use and rear caps should always be used on lenses that are not mounted on a camera.

Insider View: Canon specifically recommends against any cleaning techniques or devices that touch the surface of the layer over the imaging sensor. They do that because of the very real danger of damaging that surface. However, there are some good products that use very gentle tools to clean the sensor. You must follow their directions exactly, but I have found that they do help photographers when the gentler techniques described here don't get all the dust.

Note: You may have heard that you must turn off the camera in order to change lenses so that you will have less of a problem with dust. The reason for this idea is that if the sensor has power going to it, a charge can be built up that will attract dust, and you certainly would not want that while the lens is off your camera. However, with all Canon cameras on the market today, power is shut off to the sensor as soon as you take a lens off the camera. This means that you do not have to power down the camera in order to change lenses.

Mirror Lockup

For really critical work when using a tripod, such as shooting long exposures or working with macro and super-telephoto lenses, sharpness is improved by eliminating the vibrations caused by mirror movement. This is accomplished by locking up the mirror in advance using the EOS 50D's Mirror lockup function. However, it does mean the viewfinder will be blacked out and the only available drive mode will be Single shooting \square , no matter what drive you may have previously set.

Insider View: Keep in mind that when you shoot in Live View, the mirror is also locked up. In many cases, it might be easier just to use Live View in order to gain the benefits of no mirror bounce (from the lock up), although this does mean that you will have to use manual focus because the mirror will go down for AF, then back up again for the exposure.

Caution: Be very careful that you do not point your camera at the Sun when the mirror is locked up. The actual shutter of the camera is then exposed and sunlight focused through your lens on that shutter can damage it.

Memory Cards

The Canon EOS 50D uses CompactFlash (CF) memory cards, which are a standard in the industry and readily available. You will need a card with a sizeable capacity to handle the large image files of this camera. I can't recommend a memory card with less than 1 gigabyte (GB) for the 50D, and I would suggest one with 2 GB or more. Such cards make it easy to shoot both RAW and JPEG (a very good way of getting the best of both).

The 50D is also capable of using the full speed of a UDMA CF card. UDMA is short for Ultra Direct Memory Access and is a standard that allows high-speed transfer of image data up to two times the speed of normal cards. Such cards allow you to shoot more images consecutively at 6.3 fps (up to 90) before the camera has to pause to allow the card to catch up with pictures stored in the buffer. A fast card has no effect on the actual speed of the camera, only on how fast data is transferred from the camera's memory buffer to the memory card.

To remove the memory card from your camera, simply open the card slot cover on the right side of the camera and push the card eject button. Turn the camera off before doing this.

The cost of CompactFlash cards has dropped significantly in the past couple of years, so there is no reason not to use a high-capacity memory card to store the large image files produced by the 50D.

Insider View: Technically, the 50D will automatically shut itself off when the memory card door is opened. Plus, it will finish writing any data to a card. However, the habit of turning the camera off will ensure you are checking to be sure the camera is done recording to the card (this can take some time if you have shot a lot of images in a row). If you should open the card slot and remove the card before the camera has finished writing a set of files to it, there is a good possibility you will corrupt the directory or damage the files on the card, making the files impossible to read.

Working with Memory Cards

CompactFlash cards are very sturdy, durable devices. They are not damaged by airport security X-rays, nor are they hurt if you drop them or they fall into the water. Heat, however, will damage any type of card.

When you buy a memory card, always format it right away (see pages 65-66) when you first put it into your camera. Formatting isn't required to use the card, but it is a good way to immediately check that the card is working properly with your camera. Memory cards today are very good and rarely fail, but if they do, they usually do so right away or they simply do not work when first used. You especially should format the card if you buy a new one just before going on a trip. Never buy a card then throw it in your camera bag assuming it will work when you are far from home. You may not be able to replace it on your trip.

You may hear stories that you can wear out a memory card or that you should not erase images from your memory card as you photograph because you will erase "too much." Ignore those stories. It is extremely difficult to wear out a card or to do anything that will hurt it so that it doesn't work properly. It is possible to do things that affect the way your photos are stored on the card, however, which can make it difficult to access them. Pulling a card from a camera before it is finished writing files is one of those things.

It is true that you need to regularly format your card. If you always simply erase images, it is possible for the file and directory structures for saving images to become corrupted. Formatting cleans this up—basically defragments the card. It is also usually best to erase images from your card by using the camera, not the computer; and never format a card with your computer, only use the camera.

If you run into problems with a memory card, don't despair. Most photo labs have photo recovery software that can help. If you delete photos that you did not mean to delete, this same photo recovery software will work, but only if you refrain from shooting more images recorded to that memory card (the new photos may be recorded over the old ones).

When buying memory cards, stick with known brands. The cheap memory card that you have never seen anywhere other than the local drugstore might not be so "cheap" if it causes you problems later.

A special type of memory card is the Microdrive-type of CF-size card (sometimes called CF Type II), which is compatible with the 50D. These cards are literally tiny hard drives and will be damaged if you drop them on a hard surface or into water, although security X-rays have no effect.

Insider View: It is difficult to recommend Microdrives for still photography. They used to be a great deal because they offered so much more capacity for the money compared to CompactFlash. However, most CompactFlash memory is reasonably priced today. Due to the dependability, durability, high memory capacity, and falling relative cost of CompactFlash cards, Microdrives seem less of a bargain.

Organizing Images on the Memory Card

Most photographers never change how the camera identifies images on a memory card, and you may find this is never an issue for you. However, the 50D does let you choose how the camera deals with numbering the images on the card,

plus you can now create folders to separate shots. Having multiple folders on a memory card can help you separate types of images when you are shooting, plus you can erase only the images in a particular folder, which can also help in managing your photos.

Numbering options can be set under *File numbering* in the Set-up 1 menu **\P'**, while folders are created under *Select folder* in the same menu. The numbering options are as follows:

- 1. The numbers can go continuously from 0001 to 9999, even when you change cards.
- The camera can reset numbers every time you change the CF card.
- 3. You can force a manual reset of numbers at any time.

Continuous numbers can make it easy to track image files over a time period. Resetting numbers will let you organize a shoot by using different CF cards. There is no particular advantage to either method; it is a personal preference depending on your workflow needs.

The 50D also allows folders with up to 9999 numbers for images (I say numbers because if you erase files, the camera will still continue numbering from where it left off so that you may actually have fewer than 9999 images). Selecting Manual reset puts you back to 0001 and in a new folder. Once image 9999 is recorded, you will get a message, "Full." At that point, you have to replace the CF card (formatting it would also work, but then you would lose your images).

Formatting Your Memory Card

 the choice to OK, press $^{\text{gr}}$, and formatting will occur. You will see a screen showing the progress of the formatting. Keep in mind that formatting will erase all of the recorded images already on the card, whether they were previously protected or not!

Caution: This is a big caution. You must understand that formatting will erase all images and information stored on the card—everything, including protected images! Be sure that you do not need anything on the card to be saved before you format. If you accidentally format a card, there is software available that will allow you to recover your images if you have not saved new images over them.

Note: Formatting your CF card once in a while is a good idea to clean it and keep its data structure organized. However, you should avoid formatting the card in a computer because it may use a different file structure than a digital camera; this can make the card unreadable for the camera. If that happens, try formatting the card again in the camera.

Erasing Images from Your Memory Card

Cleaning the Camera

It is important to keep your camera clean in order to minimize the amount of dirt or dust that could reach the sensor and to keep the optics at their best. A good kit of cleaning materials should include the following: A soft camel hair brush to clean off the camera, an antistatic brush and microfiber cloth for cleaning the lens, a pack towel for drying the camera in damp conditions (available at outdoor stores), and

a small rubber bulb to blow off debris from the lens and the camera (you can get such a bulb from a camera store – the Giottos Rocket Blower is a good one). Never use compressed air.

Always blow and brush debris from the camera before rubbing with any cloth. For lens cleaning, blow and brush first, then clean with a micro-fiber cloth. If you find there is residue on the lens that is hard to remove, you can use a lens cleaning fluid (be sure it is made for camera lenses). Never apply the fluid directly to the lens, as it can seep behind the lens elements and get inside the body of the lens. Apply with a cotton swab, or just spray the edge of your micro-fiber cloth. Rub gently to remove the dirt, then buff the lens with a dry part of the cloth. Replace the cloth in its protective packet to keep it clean. You can wash it in the washing machine (and dry it in the dryer) when it gets dirty.

You don't need to be obsessive about cleaning your camera, just remember that a clean camera and lens helps to ensure that you don't have image problems. Dirt and other residue on the camera can get inside when changing lenses, which cause problems if they end up on the sensor. Dust on the sensor will show up as small, dark, out-of-focus spots in the photo (most noticeable in light areas, such as sky). You can minimize problems with sensor dust if you keep a body cap on the camera and lens caps on lenses when they are not in use.

In-Camera Processing and File Formats

The RAW format has generated a lot of discussion and excitement among photographers. It is a superb format, to be sure, but it is not for everyone. There is no question that RAW files offer excellent benefits for the photographer who likes to enhance photos in the computer and process 14-bit image files. The 50D's proprietary RAW format, CR2, can be processed with more flexibility and versatility than previous versions (but remember to upgrade your RAW converter software in order to use it).

However, RAW can require more work and time to organize, review, and process than other formats. For the photographer who likes to work quickly and wants to spend less time at the computer, JPEG may offer distinct advantages and, with the 50D, will give excellent results. Canon's unique DIGIC Imaging Engine (DIGIC for short) delivers exceptional JPEG images. Canon has long had exceedingly strong in-camera processing capabilities, and the 50D includes the latest version of their high-performance processor. DIGIC 4.

DIGIC 4 intelligently translates the image signal as it comes from the sensor, optimizing that signal as it is converted into digital data. In essence, it is like having your own computer expert making the best possible adjustments as it processes the captured RAW data for you. It works on the image in-camera after the shutter is clicked and before the photo is recorded to the memory card, improving color balance, reducing noise, refining tonalities in the brightest areas, and more.

Canon's DIGIC 4 internal processor is extremely effective at processing the sensor's signal, ensuring good tonal detail throughout an image.

Sports action may be best shot with JPEG because the camera's buffer will fill much less rapidly than when recording RAW files.

This upgraded processor also improves the 50D's ability to write image data to the memory card in both JPEG and RAW. Write speed is now faster, enabling the camera to take advantage of the benefit offered by high-speed UDMA memory cards. It is important to understand that the speed of a memory card does not affect how quickly the camera can take pictures. Rather, a card's speed rating affects how fast the camera can transfer images from its buffer (temporary memory in the camera) to the card. The faster the memory card, the faster the buffer will empty, allowing more images to be taken in sequence. This does not alter the number of frames per second (fps) the camera can shoot, but it will affect how many images can be taken in succession. If the buffer becomes full, you will see buSY message on the LCD panel and in the viewfinder, and the camera will stop shooting until the writing can catch up.

There are factors, however, that do affect how many shots per second the camera can take. It used to be that a high-megapixel sensor with its comparatively large amount of data would record at a relatively slow rate. Yet this is not true of the 50D, which can take 15.1-megapixel pictures at 6.3 fps (plus an additional drive option of 3 fps). Even when recording at maximum resolution, the camera has a burst capacity of 90 JPEG or 16 RAW frames (this will occur only with the fastest UDMA memory cards, however). The 50D is even designed to keep up with autofocus (AF) at these speeds, and it has very fast response times: 0.15-second startup, 65-millisecond (ms) lag time for shutter release, and finder blackout (when the mirror is up during exposure) of only 0.1 sec. (due to a high-speed mirror drive motor).

Picture Style

The 50D continues the use of a feature called Picture Style. While you can gain access to this through the Shooting 2 menu, the easiest way is to simply press the Picture Style button located on the back of the camera below the LCD monitor. Picture Style applies in-camera processing to an image before it is saved to the memory card as a JPEG file, which can be especially helpful if you are printing image files directly from the camera without using a computer, or if you need to quickly supply a particular type of image to a client. In addition, any Picture Style effect is tagged to a RAW file's metadata (not actually applied to its pixels), but can only be read only by Canon's image processing software.

Insider View: Not every photographer will use Picture Style, but if you need this feature's settings, you will find they work extremely well. I once led a trip to Machu Pichu and the day was cloudy and threatening rain. I knew this could result in disappointing photos. So I had some of my group set their cameras to achieve more image intensity by changing the in-camera processing parameters, which really helped them stay positive and not be disappointed in

the day. We set up custom parameters, or Picture Styles, that increased the contrast and color intensity for a "cloudy-day setting."

All of the various Picture Styles have specific effects by default, but you can fine-tune these to create custom effects. Just press to display the Picture Style screen. Each style controls the degree of in-camera image processing applied to four aspects of an image (they are also in this order on the setting screen): Sharpness, Contrast, Saturation, and Color tone. (The last two attributes, Saturation and Color tone, are replaced by Filter effect and Toning effect when the Monochrome (black-and-white) Picture Style is used

determines to the amount of sharpening that is applied to an image file by the camera. Increases or decreases the recorded contrast of the scene. Influences color richness or intensity. In helps the photographer decide how red or how yellow to render skin tones, but will also affect other colors as well.

The various Picture Styles with their default settings are:

- Standard—This makes the image look sharp and crisp. It is the only style available for the Full Auto mode

 In-camera sharpening is low to moderate.
- Portrait—This is biased toward making skin tones look attractive. The image is not as crisp as Standard, though still sharp. You can adjust the skin tone further by changing the Color tone setting. In-camera sharpening is low.
- Landscape—This style is biased toward crisp landscape photos with vivid blues and greens. Sharpening is moderate.

Insider View: The three styles above create finished images that can be easily printed directly from the camera or memory card.

The Landscape Picture Style is designed to make landscapes look crisp and sharp, with vibrant foliage.

- Neutral—Choose this style for natural colors that are less vivid and intense. No sharpening is applied.
- Faithful—This style is rather unusual. It is designed for photographing a subject under specific daylight conditions with a color temperature of 5200 Kelvin (approximately mid day in full sun). The color is adjusted to match the color temperature precisely. No sharpening is applied.

Insider View: The two styles above will typically require some work in the computer.

• Monochrome—This changes color images to black-and-white ones for JPEG, but RAW images can still be processed as color photos. In-camera sharpening is low to moderate.

Insider View: Monochrome is just another word for black and white. Technically, you can have a full-color image that is monochromatic, meaning it only has one color; but often, as it is here, monochrome is substituted to mean black and white. I find the term a little snooty—photographers doing black and white in the classic darkroom never referred to their work as monochrome.

• 1, 2, or 3 User Def. 1-3—This allows you to create three different custom Picture Styles based on your specific shooting needs.

Changing Picture Style Settings

Setting the levels for Sharpness, Contrast, and Saturation details is pretty intuitive, while Color tone may be less so. To begin, press the button to gain access to the Picture Style menu, then scroll with the Quick Control Dial (large dial on back of the camera) to select one of the styles described above. Next press the INFO. button to bring up the detail screen for setting that style's parameters. Scroll again using and press (at the center of the Quick Control Dial) to select which detail you want to adjust.

At this point, again use and to adjust your detail parameters; moving to the left applies less of the attribute, and to the right applies the setting more heavily to the image. Be wary of pushing Sharpness or Saturation to their maximum intensity (all the way to the right). This can create images that are difficult to deal with when imported to the computer. You can gain unwanted halos around contrasting edges with high sharpness, and you can lose detail in bright colors if saturation is too high. Color tone is specifically optimized for skin tone. Settings to the left are redder, to the right, more yellow. Press the total button (located on back of the camera near the upper left corner of the LCD monitor) to save these detailed settings.

Note: Very important! You can set all of these controls as much as you want and there will be no effect on the pixels of a RAW file.

While specific situations may affect where you place your control points for the these flexible options, here are a couple of suggestions to consider when making custom Picture Styles:

- Create a hazy or cloudy day setting—Make one of the Picture Style sets capture more contrast and color on days where contrast and color are weak. Increase the scale for Contrast and Saturation by one or two points (experiment to see what you like when you open the files on your computer or use the camera for direct printing). You can also increase the red setting of Color tone (adjust the scale to the left).
- Create an intensely colored slide film look—Increase Contrast two points, Sharpness one point, and Saturation by two points.

You cannot choose or change Picture Style in any of the 50D's Basic Zone modes: Portrait and Landscape automatically use their respective styles, and the Standard style is set for Full Auto, Close-up, Sports, Night Portrait, and Flash Off.

You can even download customized Picture Style files from the Camera Window software included in the box with your 50D, and Canon says the different Picture Styles are downloadable from their website (www.usa.canon.com/consumer).

Changing Monochrome Settings

You can also adjust parameters for black and white in the Monochrome Picture Style. The detail selections for Contrast and Sharpness are the same adjustments as used with the other styles. In addition, there are menu options for Filter effect and Toning effect (replacing Saturation and Color tone). Scroll to The press INFO. to access these settings.

The parameters for Filter effect offer four tonal effects that mimic what different colored filters do with panchromatic black-and-white film (a fifth setting, N:None, applies

The Orange Monochrome Picture Style is a good one to use for landscapes with a lot of sky.

no special filter effects). Each color choice in the Filter effect menu will make colors similar to your color selection look lighter, and colors opposite it on the color wheel will record darker.

Ye:Yellow is a modest effect that darkens skies slightly and gives what many black-and-white aficionados consider the most natural looking of black-and-white filters.

Or:Orange is next in intensity, between Yellow and Red, but is better explained if you understand the use of Red.

R:Red is dramatic, making rather light anything that is red, such as flowers or ruddy skin tones, while blues become dark. Skies become striking and sunlit scenes gain in contrast (the sunny areas are warm-toned and the shadows are cool-toned, so the warms get lighter and the cools get darker).

G:Green makes Caucasian skin tones look more natural, while foliage becomes bright and lively in tone.

Note: If you aren't sure what any of these do, don't be afraid to make the setting and shoot the picture. You see the effect immediately on the LCD monitor, and delete if necessary.

As opposed to the options for Filter effect, those for Toning effect add color to the black-and-white image so it looks like a toned black-and-white print. Your choices include N:None, S:Sepia, B:Blue, P:Purple, and G:Green. Sepia and blue are the traditional tones most often used in prints.

User Defined Picture Styles

If you change a Picture Style, or create a totally new one, you can "register" (Canon's term) it with the camera (save it as a preset). To do this, scroll to one of three selections for User Def. and press \mbox{INFO} . This displays the setting details. Now use the $\mbox{\ensuremath{\square}}$ and $\mbox{\ensuremath{\square}}$ to scroll through the setting sliders and change them as needed.

Picture Style Editor

The Picture Style Editor is one of several software programs that comes with the 50D and allows users to create their own Picture Style files that can be registered in the camera. Other programs bundled on the EOS Digital Solutions disk include EOS Viewer Utility and Digital Photo Professional (DPP).

To create your own Picture Style file, select and load a sample RAW image and then adjust the image characteristics based on one of the existing Picture Style settings (Standard, Portrait, Landscape, Neutral, or Faithful—but not Monochrome). The created Picture Style file can then be registered in the camera using the EOS Viewer Utility, or it can be used when converting the RAW file for viewing using DPP.

Instead of using AWB, try setting the white balance control to match the lighting conditions. This day was overcast, so the 50D was set to Cloudy WB—AWB would probably have made this picture look too blue.

White Balance

White balance is an important digital camera control. It addresses a problem that had long plagued film photographers: How to deal with the different color temperatures of various light sources. Film was "balanced" for a specific color temperature, and only when photographing in light of that temperature would colors look neutral. White balance controls how the camera responds to different colors of light so that there are no inappropriate color casts. While color adjustments can be made in the computer after shooting, especially when using RAW format, there is a definite workflow benefit to setting white balance properly from the start.

The 50D helps you do this with an advanced Auto White Balance (AWB) control that makes colors more accurate and natural than earlier D-SLRs. In addition, improved algorithms and the DIGIC 4 processor make AWB more stable as you shoot a scene from different angles and focal lengths (which is always a challenge when using any camera's automatic white balance).

While AWB will give excellent results in a number of situations, many photographers prefer the control offered by other presets and custom settings. With nine separate white balance settings, plus white balance compensation and bracketing, the ability to carefully control color balance is exceptional in the 50D. It is well worth the effort to learn how to use the different white balance functions so that you can get the best color with the most efficient workflow in all situations (including RAW). This is especially important in strongly colored scenes, such as sunrise or sunset, which can fool AWB.

Insider View: I rarely use the AWB setting. I find it is too inconsistent, especially when I change focal lengths or move around in a scene. It also frequently compromises color quality. I see this so much in my classes at BetterPhoto.com that I can often recognize AWB just from the photo. Since the RAW format allows you to easily change white balance after the shot, usually with image-processing software in the computer, some photographers believe it is not important to select an appropriate white balance at the time the photo is taken. I can't recommend that. Choosing white balance before the shot is important and does affect your workflow. When you bring CR2 files into software for "translation" from RAW to an image file such as TIFF or PSD, the RAW files are imported based on the white balance settings that you chose during initial image capture (I use the word "based" because this changes depending on the software— Canon software will use the settings exactly, while Adobe Camera Raw, for example, is an interpretation of the settings). Sure you can adjust white balance settings in the computer, but why not make a good RAW image better by merely tweaking the white balance with minor revisions at the image-processing stage rather than toil with images in a workflow that does not define white balance from the start?

The basic white balance settings are simple enough to learn that they should become part of the photography decision-making process (however, they can only be used with the Creative Zone exposure modes, see pages 158-164). In addition, the Custom white balance setting, which is more involved to set than the others, is quite valuable: It pays to understand how to use that tool for rendering the truest color in all conditions. We'll examine all the different white balance options after a taking a brief look at color temperature.

What is Color Temperature?

You will see white balance referred to as color temperature. In a simplified manner, color temperature is a scale starting at 0 that represents the color of a heated object as it gives off light. The scale is called the Kelvin scale, which is designated by a K after a number (for degrees Kelvin—however, the convention for Kelvin is to not use the degrees symbol). Color temperature is best understood if you compare two numbers. A higher number is visually cooler (bluer) than a lower number. If you have a white balance that matches a particular number, the color of the light will be neutral, and any light lower in temperature will be warm (more orange), while lights higher in temperature will be cooler (bluish). The color temperatures listed for the white balance settings below show the particular color temperature each setting is balanced for (i.e., will make that light neutral).

For example, if the scene has a color temperature of 3000K (not unusual for incandescent lighting) and the white balance is set to 5200K, it will look orange. If the white balance is set to 3200K, the scene will look neutral with a slight hint (200K) of warmth. To take another example, if the scene has a color temperature of 7000K (not unusual for open shade) and the white balance is set to 5200K, it will look a little cold (bluish). If the white balance is set to

8,000K, the scene will look a little warm. At a white balance of 7,000K, the scene will look neutral.

Insider View: In reality, this works as a general principle, but is not absolute because of the way our eyes and brain interpret the world, constantly based on our experience and expectations. A neutral scene in daylight may look cooler than it really is because we expect such scenes to look warm in photographs. That is because of a tradition of shooting those scenes in films that warm up conditions. Paul Simon didn't write Kodachrome because the film made reality neutral!

To set white balance on your 50D, press the **WB** button on top of the camera to the right of the flash, in front of the LCD panel (you don't have to hold it down). Then rotate the Quick Control Dial \bigcirc to select the desired white balance icon from the LCD panel.

White Balance Settings

Auto: Color temperature range of approx. 3000 – 7000K In this setting, the camera examines the scene for you, interprets the light it sees (in the range specified above) using the DIGIC 4 processor (even with RAW, though then it is merely metadata instructions), compares the conditions to what the engineers have determined works for such readings, and (in theory) sets a white balance to make colors look neutral (i.e., whites appear pure, without color casts, and skin tones appear normal).

AWB can be a useful-setting when you are moving quickly from one type of light to another, or whenever you hope to get neutral colors and need to shoot fast. Even if it isn't the perfect setting for all conditions, it will often get you close enough so that only a little adjustment is needed later using your image-processing software.

Insider View: While AWB is well-designed, it can only interpret how it "thinks" a scene should look, so if your wideangle and telephoto shots of the same subject change what is seen by the camera in terms of colors, the camera will readjust for each shot, often resulting in inconsistent color from shot to shot. If you have time, it is often better to choose from the preset white balance options (or Custom white balance), because colors will be more consistent from picture to picture (since the white balance is locked to a single setting).

** Daylight (approximately 5200K): This setting adjusts the camera to make colors appear natural when shooting in sunlit situations between about 10 A.M. and 4 P.M. (middle of the day). At other times, when the sun is lower in the sky and has more red light, the scenes photographed using this setting will appear warmer than normally seen with our eyes (yet, it also makes those scenes more natural based on how we have all learned to see photographs of such scenes). It makes indoor scenes under incandescent lights look very warm indeed.

Shade (approximately 7000K): Shadowed subjects under blue skies can end up very bluish in tone, so this setting makes the light look more neutral or even warms it up. The ** setting is a good one to use anytime you want to warm up a scene (especially when people are included), but you have to experiment to see how you like this creative use of the setting.

Insider View: One would think that warm is warm, but it isn't completely. The sensor always interprets colors in ways unique to how it was engineered. A good example of this is greens in trees and other vegetation—I find that Canon sensors consistently make the green too yellow, and using a Shade setting can give such colors an undesirable yellow cast.

Cloudy (approximately 6000K): Even though the symbol for this setting is a cloud, its full name is actually the Cloudy/twilight/sunset setting. It warms up cloudy scenes as if you had a warming filter, making sunlight appear warm, but not quite to the degree that Shade does. You may prefer the setting to when shooting people since the effect is not as strong. Both settings actually work well for sunrise and sunset, giving the warm colors that we expect to see in such photographs. However, figure of the strange of the set in such photographs. However, for the set in such photographs of the set in such photographs. However, for the set in such photographs of the set in such photographs.

Insider View: You really do have to experiment a bit when using these settings for creative effect. Take several photos! Taking extra pictures with a digital camera costs nothing. Make the final comparisons on the computer.

- ** Tungsten Light (approximately 3200K): is designed to give natural results with quartz lights (which are generally balanced to 3200K). It also reduces the strong orange color that is typical when photographing lamp-lit indoor scenes with daylight balanced settings. Since this control adds a cold tone to other conditions, it can also be used creatively for this purpose (to make a snow scene bluer and colder looking, for example).
- White Fluorescent Light (approximately 4000K): Though often works well with fluorescent lights, is usually more precise and predictable. Fluorescent lights most often appear green in photographs, so this setting adds magenta to neutralize that effect. (Since fluorescent lights can be extremely variable, and since the 50D has only one fluorescent choice, you may find that precise color can only be achieved with the Custom white balance setting. I you can also use creatively to add a pinkish warm tone to your photo (such as during sunrise or sunset).
- **4** Flash (approximately 6000K): Light from flash tends to be a little colder than daylight, so this warms up a daytime shot. According to Canon tech folks, this setting is very similar

Your white balance setting will affect the colors of your photograph, so it is important to select the right one. Especially indoors, where lighting conditions can sometimes be difficult to figure out, Auto WB may be the most helpful choice.

to (the Kelvin temperature is the same); it is simply labeled differently to make it easier to use. I actually use a lot, finding it to be a good, all-around setting that gives a slight but attractive warm tone to outdoor scenes.

Custom (approximately 2000–10,000K): A very important tool for the digital photographer, is a precise and adaptable way of getting accurate or creative white balance. It has no specific Kelvin temperature, but is set after measuring a specific neutral tone in the light to be photographed. It deals with a significantly wider range than (and even Kelvin , as we will learn about), and that can be very useful.

To set you choose a white (or gray or something else you know is a neutral tone) target that is in the same light as your subject and take a picture of it. You can use a piece of paper or a gray card. For precise work, avoid most white papers as they have brighteners that act like a blue tone for white balance. Your white balance target does not have to be in focus (though your camera won't fire if set to **ONE SHOT** AF and cannot focus on a target), but it should fill the image area. Be sure the exposure is set to make this object middle gray in tone; if it is too dark (underexposed) or washed out (overexposed), the Custom white balance will not work properly.

Then, go to Shooting Menu 2 and scroll to select *Custom WB*; confirm by pressing and took (the one for white balance) should be displayed in the LCD monitor, with a dialog box with a message ("Use WB data from this image for Custom WB") and options for Cancel or OK. When you scroll and select OK to import this data, a message will appear as a reminder to properly set you white balance: "Set WB to

Now you can use this measured Custom white balance setting by exiting \square : and pressing the WB button. Scroll to select \square . You have created a new white balance setting that will stay associated with the Custom choice until you repeat this process for a new subject.

The procedure just described produces neutral colors in some very difficult conditions. However, if the lighting is mixed in color, like a situation where the subject is lit on one side by a window and on the other by incandescent lights, you will only get neutral colors for the light that the white card was in. Also, when shooting in reduced spectrum lights, such as sodium vapor, you will not get a neutral white under any white balance setting.

Insider View: You can also use to create special color for a scene. For example, you could photograph a target that is not white or gray. If you used a pale blue target, your Custom white balance could generate a nice amber color for the scene, because by balancing on the blue, the camera adjusts the color to neutral, which in essence removes blue. So the scene will have an amber cast. You can use different strengths of blue for varied results. You could use any color you want for white balancing—the camera will work to remove (or reduce) that color within the range of the white balance settings. Paint chips from a paint store work great for this.

Color Temperature (set Kelvin temperature between 2500–10,000K): This setting offers a wide range of possibilities and is recommended for photographers experienced in using a color-temperature meter and color-compensation (CC) filters. In addition, it can be used in any situation where you want to warm or cool the image. It is a multistep adjustment. First press WB and scroll to select on the LCD panel. Next go to and use the Main Dial color to select your desired color temperature.

Note: Many pro photographers have used color temperature meters in their film days. Unfortunately, various meters do not read color temperature exactly the same. The Kelvin numbers for the 50D's white balance settings are approximate and cannot be precisely related to a different device's color temperature readings.

White Balance Correction

The 50D offers even additional control over white balance—there is a white balance correction feature built into the camera. You might think of this as exposure compensation for white balance. It is like having a set of color balancing filters in four colors (blue, amber, green, and magenta) and in varied strengths. Photographers accustomed to using color conversion or color correction filters will find this feature quite helpful in getting just the right color.

The setting is pretty easy to manage using a: . Scroll appear with a graph that has a horizontal axis from blue to amber (left to right) and a vertical axis from green to magenta (top to bottom). You move a selection point within that graph with the Multi-controller . You will see a visual indication on the graph as you change the position of the selection point and, at the same time, an alphanumeric display is visible in the upper right of the screen showing a letter for the color (B, A, G, or M) and a number for the setting. For photographers used to color-balancing filters, each increment of color adjustment equals 5 MIREDS of a color-temperature changing filter (a MIRED is a measuring unit for the strength of a color temperature conversion filter). This will stay adjusted in this way until you change it, so you must set the correction back to zero when conditions change.

White Balance Auto Bracketing

White balance auto bracketing is an option to use when you run into a difficult lighting situation and want to be sure of the best possible white balance settings. This is actually quite different than autoexposure bracketing (AEB). With the latter, three separate exposures are taken of a scene. But with white balance auto bracketing, you take only a single exposure, and the camera processes it to give you three different white balance options.

Note: Using white balance bracketing will slightly delay the recording of images to the memory card because the camera is processing the shot three times.

This bracketing is done up to +/- 3 levels (again, each step is equal to 5 MIREDS of a color correction filter). You can bracket from blue to amber or from green to magenta. Keep in mind that even at the strongest settings, the color changes will be fairly subtle.

The white balance bracketing will be based on whatever white balance mode you have currently selected. The selected mode's icon will blink to tell you that white balance bracketing is being used. You access white balance bracketing by selecting WB SHIFT/BKT in then press

ET . A graph screen with the horizontal (blue/amber) and vertical (green/magenta) axes will appear on the LCD monitor. Rotate the to adjust the bracketing amount to the right (clockwise) to set the blue/amber adjustment, then back past center to the left (counter clockwise) for green/magenta (press to okay the setting; press INFO. to clear). You can also shift your setting from the center point of the graph by using the

Note: The default for white balance auto bracketing records an original image at the currently selected white balance setting, then internally creates an additional set of (1) a bluer image and a more amber image, or (2) a magenta and greener image. Use C.Fn I-5 to change bracketing sequence.

Insider View: The obvious use of this feature is to deal with tricky lighting conditions where it can be tough to get the correct white balance—getting that white balance right can be important when you need to use a photo quickly and don't have time for much processing in the computer. It can also be useful when you want to add a warm touch to a portrait but are not sure how strong you want it. Select the

setting, for example, then use white balance bracketing to get the tone you're looking for (the bracketing will give you the standard Cloudy white-balanced shot, plus versions warmer and cooler than that). This effect can be pretty subtle, however—you may find slight adjustments or white balance to be more easily done in the computer.

Color Space

With all this discussion of color, you might wonder how color space fits in. Color space is a parameter of digital images that affects how color is interpreted and is a specific option that affects how color is recorded to JPEG files (it is chosen later for RAW files as you process them in the computer). The 50D offers two choices, sRGB and Adobe RGB. In spite of what you might hear, both actually give excellent color for digital images. Adobe RGB is the larger color space (larger gamut, wider color variations) and offers more capability for the photographer who wants to make adjustments to color in the computer. Often, though, Adobe RGB needs that adjustment in the computer for it to look right, so direct printing from this color space can be disappointing.

sRGB is a smaller color space and so has less flexibility for color adjustment in the computer. However, it tends to look good without adjustments, so direct printing from this color space can look quite good.

Color space is chosen from **Q**: . Scroll to *Color space*, press (st) , then choose the desired color space and press (st) again.

Remembering Camera Settings

The EOS 50D offers two ways to record how your camera is set up so you can go back to those settings again and again: (1) The settings for C1 and C2 on the Mode Dial; and (2) My Menu *, one of the menu tabs. Canon calls this "registering" your camera settings (which seems to me an odd connotation for this word, but that's what it is). Whatever you call them, the C1 and C2 settings provide a handy way to create two different ways of setting up your camera for different purposes. You can save your camera's settings including, mode, metering mode, custom functions and more.

Insider View: I find this feature really helpful when I use it. It allows me to set up the camera for optimum use for a certain subject or type of photography that I might shoot with regularity, say close-ups. The camera remembers those settings so I don't have to constantly reset them when I come back to this subject after shooting something else.

The C settings on the Mode Dial are saved (or registered) as follows: First choose and set all of the camera controls needed for a particular type of shooting. Next, go to Set-up 3 menu **\P:** and scroll to Camera user setting. Press and select Register, then scroll to the C setting you want (C1 or C2) and press again. You can clear this at any time by creating a new setting or by selecting Clear settings instead of Register earlier in the menu. Now your camera will go instantly to the functions you have chosen anytime you selected the registered C setting.

My Menu \bigstar is sort of like the C settings, except this is about getting to a specific camera function quickly through the use of menu system. In other words, instead of always searching and scrolling for something in the menus that you use all the time, you can place it here so it is easier and quicker to find.

Insider View: I find My Menu is really helpful. I like to use

→ , for example, but find it quicker and easier to find when I put it here. I also include AEB and Mirror lockup. My Menu lets me get to these controls much more easily than always going through the entire menu structure.

Setting up My Menu is quite easy. Go to the \bigstar menu tab, select My Menu settings, then scroll to select Register. You then get a long list of menu items. Scroll through them and select what you want by pressing (F), up to six total selections.

Checking Camera Settings

You can always display your camera settings in the LCD on the back of the camera by pressing the INFO. button. As you press it, you get two different screens. The first shows information about how the camera is prepared to deal with your image file, including the use of Picture Styles, color space, size of the memory card, and more. The second displays the new Quick Control screen that shows actual shooting settings, including exposure mode, exposure compensation, ISO setting, AF, white balance, and more. You can use the the controls.

Insider View: I don't find the first screen all the useful. It has things on it that most photographers don't change much. The second screen is helpful for aging baby-boomer eyes, or frankly, anyone when the camera is on the tripod and you want to check settings at a glance. However, the placement of the INFO. and buttons right next to each other is a little awkward—I tend to push when I really want INFO.

The 50D File Formats

The Canon EOS 50D records images as either JPEG or RAW files. It is important to understand how the sensor processes an image. It sees a certain range of tones coming to it from the lens. Too much light, and the detail is washed out; too little light, and the picture is dark. This is analog (continuous) information, and it must be converted to digital (which is true for any file format, including RAW or JPEG). The complete data is based on 14-bits of color information, which is changed to 8-bit color data for JPEG, or simply placed virtually unchanged into a 16-bit file for RAW. (A bit is the smallest piece of information that a computer uses—an acronym for binary digit. Data of eight bits or higher are required for true photographic color.) This occurs for each of three different color channels employed by the 50D: red, green, and blue. RAW files have very little processing applied by the

The larger bit-depth of RAW files can be helpful when dealing with an image that has subtle white or black tones.

camera. The fact that they contain 14-bit color information is a little confusing since this information is put into a file that is actually a 16-bit format.

Both 8-bit and 16-bit files have the same range from pure white to pure black because that range is influenced only by the capability of the sensor. If the sensor cannot capture detail in areas that are too bright or too dark, then a RAW file cannot deliver that detail any better than a JPEG file. It is true that RAW allows greater technical control over an image than JPEG, primarily because it starts with more data (14-bits in a 16-bit file), meaning there are a huge number of additional "steps" of information between the white and black extremes of the sensor's sensitivity range. These steps are especially noticeable in the darkest and lightest areas of

the photo, allowing you to pull more detail from those areas, but—and this is important to understand—that detail must have been within the range of the sensor. So it appears the RAW file has more exposure latitude and allows the possibility of greater adjustment to the image before banding or color tearing becomes noticeable.

JPEG format compresses (or reduces) the size of the image file, allowing more pictures to fit on a memory card. JPEG algorithms carefully, and really quite smartly, look for redundant data in the file (such as a large area of a single color) and reduce that duplication of data, while keeping instructions on how to reconstruct the file. JPEG is therefore referred to as a "lossy" format because technically, data is lost, but the computer will rebuild the lost data quite well as long as the compression is low.

It is essential to note that both RAW and JPEG files can give excellent results. Photographers who shoot both use the flexibility of RAW files to deal with tough exposure situations, and the JPEG format when they need fast and easy handling of images. Which format will work best for you? Your own personal way of shooting and working should dictate that. If you are dealing with problem lighting and colors, for example, RAW will give you much more flexibility in controlling them. If you need the utmost in control for processing your photos in the computer, RAW is best. If you need quick access to your photos (for example, printing directly from a memory card), JPEG may be more efficient.

RAW Exposure Processing

JPEG processing is easy. You can do it with any image-processing program. However, not all such programs can open RAW files; special software is required to convert from RAW. Canon does supply Digital Photo Professional that is specifically designed for CR2 files and allows you to open and smartly process them.

For best results, use the highest quality image settings: either RAW or the Large/Fine option for JPEG.

Insider View: Digital Photo Professional is an excellent program that does a great job with CR2 files. There are also a number of other RAW conversion programs available that are very good. For example, Photoshop ® Camera Raw from Adobe does an exceptional job, and is tightly integrated into Photoshop, so for me, it is an extremely work-efficient program. I also like Adobe's Photoshop Lightroom™ 2, which is my favorite program for quickly editing, sorting, and processing RAW files. One problem that you will run into is that older versions of RAW processing software might not open your 50D CR2 files. These are new files and you need an upgraded version of your software in order to open them.

Whatever method you choose to gain access to RAW files in your computer, you will have excellent control over the images in terms of exposure and color of light. RAW files capture the maximum amount of data from your sensor. This data is not constructed into a photograph until you convert it in a RAW conversion program. When converted, this large amount of information allows you to change tonal and color values in a photo without causing harm to the file. Most RAW software allows batch processing. This allows you to adjust a group of photos to specific settings and can be a very important way to deal with multiple photos from the same shoot.

Image-Recording Quality

The EOS 50D offers a flexible set of choices for image-recording quality, consisting of combinations of different file formats, resolutions, and compression rates. But most of the time you will shoot the maximum image-file size using RAW or the highest quality JPEG setting. There is little point in shooting smaller image sizes except for specialized purposes. After all, the camera's high resolution is what you paid for!

At the bottom of the screen are the JPEG options. These are chosen with the Quick Control Dial . The first setting (again, an icon that looks like a hyphen or minus sign) means no JPEG files will be recorded. Next you will see two choices for the full image size (or full resolution—L): one for

a file compression level of fine ($\blacksquare L$ —less compression/higher quality), and one for normal (more compression) $\blacksquare L$. Then you will see a smaller image size (M), also with two compression options, one for fine $\blacksquare M$ and another for normal $\blacksquare M$. And finally you will see the smallest image size (S) options: $\blacksquare S$ and $\blacksquare S$. Most photographers usually use $\blacksquare L$ when recording JPEGs.

Insider View: I am ambivalent about the use of sRAW files. Try them for yourself and see if you like using this format, but I don't see most photographers using the smallest of the RAW files.

File Quality and Card Capacity

Each quality choice does influence how many photos can fit on a memory card. Most photographers will be shooting with large memory cards because they will want the space required by the high-quality files delivered by this camera. It is impossible to give exact numbers of how many JPEG images will fit on a card because JPEG compresses each file differently depending on what is in the photo and how it can be compressed. For example, a photo with a lot of detail will not compress as much as an image with a large area of solid color.

That said, you may use the chart below to give you an idea of how large these files are and how many images might fit on a memory card of 2 gigabytes (GB)—though JPEG values are always approximate. Also, the camera does use some space on the card for its own purposes, so you do not have access to the entire capacity of 2 GB for image files.

File Capacities for 2GB Memory Card

Quality	Resolution (megapixels)	File Size (megabytes)	Approx Shots (2GB card)
4 L	15.1	5.0	370
#L	15.1	2.5	740
4 M	8.0	3.0	620
⊿ M	8.0	1.6	1190
45	3.7	1.7	1090
₫ S	3.7	0.9	2040
RAW	15.1	20.2	91
SRAW 1	7.1	12.6	140
SRAW 2	3.8	9.2	200

You can immediately see one advantage that **4L** gives over with in terms of storage: It allows you to save over 4 times the number of photos (370:91) to your memory card.

Camera Menus and the LCD Monitor

Though many of the EOS 50D's settings can be accessed or programmed by buttons and dials on the camera's body, a number of important functions are found only by using the menus that are displayed on the camera's LCD monitor. The large 3.0-inch monitor of the 50D is fantastic for viewing the menus; not only are they larger, but the high resolution of the LCD makes them easier to read as well.

While most controls on the 50D menus will be familiar to digital photographers, Canon has made an effort to display them in a readable and user-oriented fashion on this new model. Few photographers use all of them, but all of them have uses for at least some photographers.

Navigating the Menus

All menu controls, or items, are grouped into five categories, based on their use. These intuitively named categories, in order of appearance within the menu system, are Shooting, Playback, Set-up, Custom Functions, and My Menu. To make them easier to follow, they are also color-coded: red for Shooting, blue for Playback, yellow for Set-up, orange for Custom Function, and green for My Menu. And Canon has broken these further into two Shooting, two Playback, and three Set-up menus, allowing you to see all menu items on the screen at once for a given category, so you don't have to scroll to find them.

The 50D's shooting menu includes important settings that give you control over the quality of your images, such as shooting RAW or what quality of JPEG to use.

Insider View: I really like the way the menus are set up so that you can instantly see all options within any given menu without scrolling. I have used many digital cameras where this wasn't true, and it seemed I would always guess wrong about location when I wanted to find a less-used menu control, meaning I'd often have to scroll through several menus until I found it. This system lets you simply jump from menu to menu while you scan what appears on the screen. The Multi-controller of located on the back of the camera near the top right corner of the LCD monitor, also makes this very easy to do.

The MENU button is located on the back of the camera, near the top left corner, and provides quick access to the menu controls.

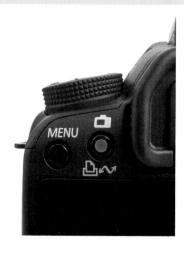

Push the waw button (located on the back of the camera next to the top left corner of the LCD monitor) to gain access to the 50D's menu screen. The first time you do this after turning on the camera, the Shooting 1 Menu a will appear.

The category menus are designated by their icon on the tabs at the top of the menu screen on the LCD monitor. You actually see all of the icons; one highlighted for the category presently in use, and the rest slightly grayed out. Move horizontally from category to category according to tabs by using the

Once you have jumped or scrolled to arrive within a menu category, rotate the Quick Control Dial (\bigcirc , the large dial on the back of the camera) to select desired items and sub items, and press the \bigcirc button (in the middle of the \bigcirc) to choose or confirm these options. To get out of the menus, simply press the shutter release slightly (you can also press \bigcirc).

The dial is also a convenient tool to use to navigate the menu system. With this single, joystick-like control, you can steer through the menus without touching any other button. You can move from menu to menu by pushing the controller side-to-side. You can scroll up and down in a menu by pushing it top-to-bottom. Finally, you can choose or set a control by pushing in on the controller.

The Quality setting in the Shooting Menu includes critical choices regarding how much information your image files will retain once they are created and saved to the memory card.

Shooting 1 Menu (Red)

- Quality (set JPEG resolution and compression level, plus RAW).
- Red-eye On/Off
- Beep (signal for controls on or off).
- Shoot w/o card (this allows you to test the camera when no memory card is in it).
- Review time (how long image stays on LCD monitor after shot).
- Peripheral illumin. correct. (peripheral illumination correction—this corrects for darkening or vignetting in the corners of the image from certain lenses).

Shooting 2 Menu (Red)

- Expo.comp./AEB (exposure compensation and auto exposure bracketing in 1/3 stop increments).
- White balance (can select WB here instead of using WB button on top right shoulder of camera).
- Custom WB (manually set white balance).
- WB SHIFT/BKT (for bracketing and shifting white balance in nine levels).
- Color space (sRGB or Adobe RGB).
- Picture Style (uses photo subjects and styles to set up different profiles for processing images in-camera).
- Dust Delete Data (records special image to use with Canon's Digital Photo Professional software to remove dust spots).

Note: All menu items will only display when the camera is in the Creative Zone (modes P, Tv, Av, M, A-DEP, C1 and C2).

Playback 1 Menu (Blue)

- Protect images (prevents images from being erased except when the memory card is being formatted).
- Rotate (rotate image so vertical photo will display vertically).
- Erase images (select and erase individual files or all files on the memory card).
- Print order (creates instructions for DPOF images).
- Transfer order (selects which images are transferred to computer).

Playback 2 Menu (Blue)

- Highlight alert (blinking area on image in LCD shows where highlights are overexposed).
- AF point disp. (turns on or off display of AF points in the viewfinder).
- Histogram (choose between Bright (luminosity) and RGB histograms).
- Slide show (automatic slide show on LCD monitor; can also be displayed on a high definition television).
- Image jump w/ (sets how many images you can jump among by using the Main Dial).

♥ Set-Up 1 Menu (Yellow)

- Auto power off (controls when the camera turns itself off after being idle for a certain time).
- Auto rotate (affects how verticals are displayed in the LCD monitor).
- Format (very important, used to initialize and erase the card).
- File numbering (three options to affect how files are numbered by the camera).
- Select folder (create and choose a folder).

Insider View: There are two additional options that will appear in the menu when a particular accessory, the WFT-E3/E3A, is attached to the camera. These pertain to an evolving technology that has been developed by Canon for file transfer that will most likely be of much more use in the future.

\(\): Set-Up 2 Menu (Yellow)

- LCD brightness (choose from seven levels).
- Date/Time
- Language (25 options).
- Video system (for playback of images on a TV).
- Sensor cleaning
- Live View function settings (controls Live View on LCD).

\(\varphi\): Set-Up 3 Menu (Yellow)

- INFO. button (affects how INFO. displays shooting information on the LCD).
- Flash control (adjusts flash settings).
- Camera user settings (setting up the C-settings on the Mode Dial).
- Clear settings (settings go back to default).
- Firmware Ver. (used when updating camera's operating system).

You can set a great number of settings with various Custom Functions menus, including those that control how ambient light is rendered while you use a flash unit.

Custom Functions (C.Fn) Menu (Orange)

This menu allows you to customize settings and is further divided into four groups of custom functions (see pages 105-116).

- C.Fn I: Exposure (functions that influence exposure).
- C.Fn II: Image (functions that are related to how the image is formed).
- C.Fn III: Autofocus/Drive (functions that are related to autofocus and how the camera shoots from image to image).
- C.Fn IV: Operation/Others
- Clear all Custom Func. (C.Fn) (put the Custom Functions back to their default settings).

★ My Menu (Green)

• A customizable menu described on page 90.

Custom Functions

Custom functions allow you to fine-tune your camera's controls. This screen shot shows each of the categories of custom settings available on the 50D.

Like most sophisticated digital cameras, the Canon EOS 50D can be customized to fit the unique needs and personality of a photographer. This is done through the Custom Functions Menu and its submenus. Some photographers never use these settings, while others use them all the time. The camera won't take better photos by changing these settings, but Custom Functions may make the camera easier for you to use.

C.Fn I: Exposure

C.Fn I-1 Exposure level increments

This sets the size of incremental steps for shutter speeds, apertures, exposure compensation, and autoexposure bracketing (AEB).

0: 1/3 stop (default)

1: 1/2 stop

Insider View: I think 1/3 stop is too small to really make a difference for most photography, so I use 1/2 stop.

C.Fn I-2 ISO speed setting increments

This function changes the size of the steps used when setting ISO speed

0: 1/3 stop (default)

1: 1 stop

Insider View: You have to be doing some pretty precise work to select 1/3 stop. 1 stop is fine and makes changing ISO speed easier.

C.Fn I-3 ISO expansion

This expands the ISO range of the camera to 6400 and 12800.

0: Off (default)—ISO expansion is turned off.

1: On—this expands the ISO settings to include 6400 (shows as H1 in the ISO part of the top LCD panel) and 12800 (shows as H2).

Insider View: Be very careful in expanding your ISO. You don't want to accidentally use one of these very high settings as they can be very noisy.

C.Fn I-4 Bracketing auto cancel

0: On—bracketing will be canceled if you change the lens, turn the camera off, or replace the battery or the CF card.

1: Off—AEB and WB-BKT settings will stay selected even if you turn off the camera.

C.Fn I-5 Bracketing sequence

This allows you to set the order of bracketing for exposures and white balance, or to cancel bracketing.

- **0**: (0, -, +)—exposures will be made in this order: metered exposure, underexposure, and overexposure. White balance will be the set WB, then cooler (more blue) and warmer (more amber); or more magenta and green (the bias is dependent on how you set it up—see pages 87-88 for more on WB bracketing).
- 1: (-, 0, +)—exposures will be made in this order: underexposure, metered exposure, and overexposure, with auto cancellation. White balance will be cooler (more blue), the set WB, and warmer (more amber); or more magenta, the set WB, and more green.

C.Fn I-6 Safety shift

You can allow the camera to smartly shift exposure when shooting in Av or Tv modes, even if the brightness of the scene exceeds the camera's capabilities at the chosen aperture or shutter speed.

- **0**: Disable (default)—this locks in the chosen f/stop for Av, or the shutter speed for Tv, regardless of conditions.
- 1: Enable Tv/Av—this choice lets the camera automatically shift f/stop or shutter speed to get a good exposure.

C.Fn I-7 Flash sync. speed in Av mode

This sets up Aperture-priority AE mode to either continue to meter and use exposures for the scene, even when flash is used, or to simply use the sync. speed of 1/250 second when flash is on.

- **0**: Auto (default)—this keeps the meter working and matches a shutter speed to the f/stop for the actual conditions of the scene.
- 1: 1/25 1/60 sec. auto—this limits the range of shutter speeds that the camera will choose when set to Av and flash is used.
- 2: 1/250 sec. (fixed)—this locks a shutter speed so essentially exposure is only based on the light from the flash.

Use C.Fn II to determine how and when the Long exposure noise reduction feature will operate.

Insider View: This is an interesting set of choices. The default allows existing or ambient light to be included as a part of the exposure with your flash. This can make flash pictures look more natural, however it can also mean that the camera chooses very slow shutter speeds. The slow shutter speed can result in blurry images from the existing light while the flash gives a sharp image that looks like a double exposure. This can be a great effect or it can be a terrible mistake. Option 2 fixes the shutter speed at the fastest possible sync speed for the camera, which will minimize this blurred effect. Option 1 is a slight compromise that does allow some slower shutter speeds, but will not really give much of an effect when light is low.

C.Fn II: Image

C.Fn II-1 Long exposure noise reduction

Choices for adding noise reduction to long exposures.

0: Off (default)

1: Auto—for exposures of one second or longer, the camera looks for noise and automatically applies noise reduction if found. However, this does add processing time, which may slow the camera; while it is in progress, image playback and menu use is not possible.

2: On—noise reduction is applied to all exposures of one second or longer, even if noise is very low and would not be detected under setting 1 above. This means every long exposure will likely slow down the camera as it processes the noise reduction.

Insider View: Noise reduction during long exposures is a function worth using if you need it, especially for night photography. However, it will increase the in-camera processing times to about the same time as your exposure.

C.Fn II-2 High ISO speed noise reduction

This applies noise reduction for high ISO settings. The first three options reduce the noise in the image at all speeds, but this is most noticeable at high speeds. At slower speeds, some noise reduction is applied to the shadows where noise can sometimes be a problem. The difference among these settings is in how much noise is affected. Stronger noise reduction will increase the processing needed in camera (including with RAW).

0: Standard (default)

1: Low

2: Strong

3: Disable—disables noise reduction

C.Fn II-3 Highlight tone priority

This setting allows the camera to make better use of its 14-bit depth in its internal processing in order to deal with bright parts of the picture.

0: Disable (default)

1: Enable—this can improve how the highlight detail is captured and interpreted by the in-camera processing. The dynamic range of the camera's interpretation of the image is increased for the bright areas. This affects JPEG images and is not applied to RAW.

C.Fn II-4 Auto Lighting Optimizer

This setting allows the camera to also make better use of its 14-bit depth in its internal processing, but here it is for dealing with dark or images with a good deal of contrast.

0: Standard (default)

1: Low

2: Strong

3: Disable

Insider View: To be honest, I have not been impressed much with this feature. It is supposed to brighten dark images or dark areas of a contrasty picture, but in many cases it doesn't do much. That doesn't necessarily make this a function to avoid, but I do think you have to be careful if you choose this so that you don't start thinking the camera will do more for

difficult lighting situations that it can. In many cases, you're simply going to have to find a better light for your subject than rely on this.

C.Fn III: Autofocus/Drive

C.Fn III-1 Lens drive when AF impossible

When AF is on, sometimes the camera can't lock focus. The camera can keep trying to find focus or stop:

0: Focus search on (default)

1: Focus search off—this stops camera from getting more and more out of focus as it attempts to refocus in situations where focus will not lock.

Insider View: It can be very annoying to have a lens go backand-forth multiple times trying to find focus in a tough situation, such as a dark space or against bright light. This lets you turn off that searching. Then when the camera can't find focus, you can switch to Manual focus.

C.Fn III-2 Lens AF stop button function

This is a specialized function to modify how autofocus is controlled by certain telephoto lenses with an AF stop button. If your lens does not have this button, this function is meaningless.

- **0**: AF stop (default)—this is simply standard autofocus, but you can stop autofocus by pushing the AF stop button.
- 1: AF start—autofocus operates only when the AF stop button on the lens is pressed. AF operation with the camera itself will be disabled while the button is pressed.
- 2: AE lock—the AF stop button locks exposure if it is pressed while metering is still active. This selection is great if you want to meter and focus a scene separately.
- 3: AF point: M to Auto/Auto to center—holding down the AF stop button will switch the camera from manual AF point selection to automatic AF point selection, but only while you hold it down.

- 4: **ONE SHOT** to **AI SERVO**—this choice enables the AF stop button to switch the camera from **ONE SHOT** AF mode to **AI SERVO** AF mode as long as the button is held down.
- 5: IS start—with the lens' IS switch turned on, the Image Stabilizer only operates when you press the AF stop button.

C.Fn III-3 AF point selection method

This changes how AF points are selected manually.

- **0:** Normal (default)—the AF point is selected using the AF point selection button and the . . .
- 1: Multi-controller direct—this lets you select AF point using just the . The is used to set the camera back to auto AF point selection.
- 2: Quick Control direct—this lets you use the of for AF point selection. However, you must push to use the for exposure compensation.

C.Fn III-4 Superimposed display

This changes how the AF points appear in the viewfinder.

- On (default)—this illuminates or highlights the appropriate AF point when the camera locks focus (or points, depending on the AF mode).
- 1: Off—turns off the illumination. Some photographers find the illuminated point distracting. The AF point will still light when you select it manually.

C.Fn III-5 AF-assist beam firing

This controls the AF-assist beam on a dedicated EOS Speedlite.

- **o**: Enable (default)—the AF-assist beam is emitted whenever appropriate.
- 1: Disable—this cancels the AF-assist beam, which can be useful in sensitive, low-light situations.
- 2: Only external flash emits—this cancels AF-assist with the built-in flash, but uses it for external flash.

Mirror lockup can help ensure sharp photos when shooting in low light conditions, such as this just-before-sunrise shot.

C.Fn III-6 Mirror Lockup

This Custom Function turns Mirror lockup on or off.

- **0**: Disable (default)—the mirror functions normally.
- 1: Enabled—the mirror will move up and lock in position with the first push of the shutter button (press fully). With the second full pressing of the shutter button, the camera will then take the picture and the mirror will return to its original position. This can minimize camera movement for critical exposures using long telephoto lenses. After 30 seconds, this setting automatically cancels.

Insider View: A lot of nature photographers like this setting when shooting any shutter speed longer than about 1/20 second with any lens, always while on a tripod. This can be helpful in minimizing camera vibration that can cause unsharp photos. After the shutter has been open for more than a couple of seconds, though, it has no real effect because the vibration from the mirror is a minor fraction of time compared to the whole exposure.

C.Fn III-7 AF Microadjustment

Caution: This is not for all photographers. It is meant as a very specific way of correction when there is a problem with a lens or camera body. Using this function can actually cause focus problems for your photography.

This custom function allows you to make fine adjustments with respect to the way autofocus works for a specific point of focus. It is designed for professionals who have older lenses that do not always function perfectly with autofocus. It is not an easily used function. If you feel you really need to do it, I would highly recommend you read the camera manual and talk to a Canon user who has used the function.

C.Fn IV: Operation/Others

C.Fn IV-1 Shutter button/AF-ON button

This helps control how the AF-On button functions.

0: Metering + AF start (default)

1: Metering + AF start/AF stop—you can both start and stop autofocusing by pressing AF-ON.

2: Metering start/Metering + AF start—this makes AF-ON start and stop AF focusing in the AI SERVO AF mode, then the exposure is set at the moment the picture is taken.

3: AE lock/Metering + AF start—this setting lets you use AF-ON for metering and autofocus, then when you press the shutter button halfway, autoexposure is locked.

4: Metering +AF start/Disable—this turns AF-ON off.

C.Fn IV-2 AF-ON/AE lock button + switch

This switches the functions of the AF-ON and AE lock buttons.

0: Disable

1: Enable—this switches the functions of the AF-ON and AE lock (*\frac{\dagger}{\dagger}) buttons buttons.

Insider View: I am not sure why most photographers would want to do this. This would make the controls rather confusing.

C.Fn IV-3 Assign SET button

This function allows you to assign different functions to the button.

- **0**: Normal (disabled)
- 1: Image quality—press and use the Main and us
- 2: Picture Style—press ® to display the Picture Style Menu.
- 3: Menu display—this makes set act like MENU.
- 4: Image replay—this makes ® act like the button.
- 5: Quick Control screen—this makes ౕ display the Quick Control screen. Use the to select a function, then the or dials to set it.

C.Fn IV-4 Dial direction during Tv/Av

This allows you to change the way the dial movement affects the shutter speed and aperture controls.

- 0: Normal
- 1: Reverse direction—does pretty much what it says to the and dials.

C.Fn IV-5 Focusing Screen

This must be used when you change focusing screens. You simply match the setting to the name of the screen type.

- **0**: Ef-A
- **1**: Ef-D
- **2**: Ef-S

C.Fn IV-6 Add original decision data

This specialized setting is used by police and other law organizations.

- **0**: Off (default)
- 1: On—this turns the feature on so that data for verifying that images are original are added to the image file. To read this data, you need to obtain the Original Data Security Kit OSK-E3.

By default, the 50D's FUNC. button, when pressed, allows you to adjust the brightness of the LCD screen, but you can assign it one of four other functions using C.Fn IV.

C.Fn IV-7 Assign FUNC, button

This setting allows you to change the use of the FUNC. button for displaying menus directly in the LCD.

0: LCD brightness—pressing FUNC. displays the *LCD* brightness menu (in **♀**:).

1: Image quality—pressing FUNC. brings up the *Quality* menu (in •).

2: Exposure comp/AEB setting—pressing FUNC. brings up the *Expo. Comp./AEB* menu (in **D**:).

3: Image jump w/Main Dial—pressing FUNC. brings up the Image jump w/ (in).

4: Live view function settings— pressing FUNC. brings up the *Live View function settings* menu (in **Y**:).

Insider View: This can be very helpful when there is a certain function that you constantly change with the camera. For example, I do some HDR (high dynamic range) photography, requiring me to shoot multiple exposures of a single scene (because it has a wide range of tones from black to white) in order to produce a realistic rendering of that scene in the computer. I use AEB to do that, so it is very easy for me to set FUNC. for AEB, then just press it to get to that set of menu items.

You can use the 50D's high resolution, 3-inch LCD monitor to view your photos and even to check exposure and focus.

The LCD Monitor

The LCD monitor is one of the most useful tools available when shooting digital, giving access to your images immediately after recording them. The 50D's 3-inch, high-resolution monitor is a big step in making this part of the camera even more usable for photographers. Until recently, you could not use the LCD monitor to view your subject in real time before shooting, as you can on compact and point-and-shoot digital cameras. The standard D-SLR uses a mirror to direct the light from the lens to the viewfinder so that the sensor is not active until the exposure is made (and therefore cannot send an image to the LCD). At exposure, the mirror pops up so the sensor can capture an image from the lens. The Live View function pops the mirror up and makes the sensor active so that the LCD displays exactly what the sensor sees through the lens in real time.

Your LCD gives you instant feedback on your photos, such as whether or not your subjects were facing the right way.

LCD Instant Image Review

An important use of the 50D's LCD monitor is for review and editing (deleting unwanted images). You can choose to instantly review the image you have just shot, and you can also look at all of the images you have stored on your memory card. Most photographers like the instant feedback of reviewing their images because it can confirm whether or not the picture is OK.

It is important to set the length of time needed to review the images you have just captured and not simply accept the default setting. It is frustrating to be examining a picture and have it turn off before you are done. You can set the duration for instant review from among several choices that include 2 sec., 4 sec., 8 sec., or Hold, all controlled by the item for Review time in (color code Red). You also use this

menu item to activate the *Off* option, which saves power by turning off the LCD monitor, but does not allow you to review the images (this does not affect playback of images, but only the instant review right after a picture is taken).

Insider View: Most manufacturers have a default setting of two seconds for image review, but this is crazy! That is way too short—you can't really evaluate very much about your picture in two seconds. I recommend 8 sec. That really won't affect your battery usage much. You can always turn the review off sooner by pressing the shutter button.

The *Hold* setting is good if you like to study your photos, because the image for review remains on the LCD monitor until you press the shutter button. But be careful, if you forget to turn off the monitor, your batteries will wear down.

Tip: There is a trick not detailed in the camera manual that lets you "hold" the image even when the duration is not set to *Hold*. As the image appears for review, press the Erase button located in the row of buttons below the LCD monitor on the back of the camera. This will leave the image on as long as you want. Ignore the *OK* and *Cancel* commands (you are not trying to erase the image yet). Press the shutter button to turn the review image off.

Playback

Reviewing images at any time on the LCD monitor is an important benefit of digital cameras. To see your most recent shot, and also any (or all) of the photos you have stored on the CF card, press the Playback button on the back of the camera below the left corner of the LCD monitor. The last image you captured will show on the LCD monitor. You then move from photo to photo by rotating the

Note: Buttons and other controls on the camera with blue-colored words or icons access Playback functions.

With the 50D, you can play back images recorded to the CF card in four different display formats or styles on the LCD by progressively pushing INFO., also found on the back of the camera below the LCD monitor:

- 1. Single image display—The image review covers the entire LCD screen and includes a band of data along the top for shutter speed, aperture, folder, and image file number.
- 2. Single image plus recording quality info—The image for review and information is as above, but adds superimposed information at the bottom to show image recording quality plus the number of the shots on the card.
- 3. Full shooting information and histogram—A thumbnail of the image is shown with a histogram and expanded data about how the image was shot (such as the date and time, white balance, ISO speed, image recording quality, exposure, and more); this can be very useful for checking what settings are working for you. The thumbnail also includes a Highlight alert function that blinks where areas are overexposed.
- **4. Shooting information and multiple histograms**—This shows less shooting information than the previous display, but adds the split RGB histograms (one each for red, green, and blue).

Whichever of these formats you last selected is the way that the image will next be displayed on the monitor.

Insider View: The full-area image of #1, and the histogram display of #3, are the most useful screens for most photographers. Unfortunately, you have to scroll through all of them to get to these. It would be nice if camera manufacturers would give choices about whether or not to display a feature, rather than just adding features to the camera.

Pressing the shutter button halfway will stop playback by turning the LCD monitor off, making the 50D ready to shoot again. You can also stop the playback and turn the LCD monitor off by pressing the

Insider View: You may have discovered that you can adjust the brightness of the LCD monitor in the menu, though this is probably not a good idea. That brightness can change the monitor in such a way that you will find the image harder to evaluate. The best thing to do in order to read the LCD better is shade the monitor in bright light by using your hand, a hat, or your body to block the sun.

Automatic Image Rotation

As in all Canon EOS D-SLRs, the 50D lets you automatically rotate vertical images during instant review or during Playback so they appear up-and-down rather than sideways in the LCD monitor when the camera is held in a horizontal position. This is the default way the camera works. To select the Auto rotate command, go to Set-up 1 Menu for and scroll to Auto rotate. Press for and you get three choices: On On (Auto rotate for both camera and computer); On On (rotate for computer only); and Off.

Insider View: I am not sure why most camera manufacturers make Auto rotate the default function for the camera. Most camera owners have no idea that this can actually be changed or should be changed. Yet the Auto rotate feature means that you are using less than the full capabilities of the camera you paid for. The problem is the size of the image when it displays in the LCD monitor. To rotate a vertical image to fit in the horizontal frame of the monitor, the picture size has to be reduced considerably and becomes harder to see. I used to always keep Auto rotate off so the largest image possible showed up in the LCD monitor, even if I did have to rotate the camera to see it properly. I really like the 50D's choice for On On , because the image displays full size in the camera's LCD monitor while it will rotate on the computer screen (with programs that recognize this command in the file's metadata—most now do).

You can rotate any image later, after the shot, by choosing *Rotate* in the Playback 1 Menu • , but again, this does not use your camera's monitor to its best capability.

Magnifying the Image

You can make the image larger on the LCD monitor by factors of 1.5x to 10x. This magnifying feature can help you evaluate sharpness and exposure details. Press the Magnify button \mathfrak{A} (located on the back of the camera in the top right corner) repeatedly to progressively enlarge the image. Press the Reduce button \mathfrak{A} to shrink magnification (located next to \mathfrak{A}). You quickly return to full size by pushing \mathfrak{A} .

Use the to scroll within the magnified image in order to look at different sections of the picture. This dial will also allow you to jump from one image to another at the same magnified view so you can compare sharpness at a particular detail, for example.

Insider View: Be aware that you can move from photo to photo in a magnified view. Every once in a while, when shooting and reviewing madly, I forget about that. Then when I change from one photo to another in Playback, I am puzzled by what I see. Sometimes I think the composition is off and I just delete the photo, only to realize I was not seeing the whole image.

File Numbering and New Folders for Images

Image files on your memory card are automatically numbered from 0001 to 9999. However, the EOS 50D gives you several options to choose how these numbers are applied to the images. Changing numbering can be useful if you are working from multiple memory cards and want to ensure the image file names are distinct. You have three numbering choices: *Continuous, Auto reset*, and *Manual reset*. These are all selected in Set-up Menu 1 under *File numbering*.

Continuous file numbering keeps numbers going in sequence regardless if you change the memory card. This

ensures that your numbers are different as they come into the computer from a particular shoot even if you use more than one card. If you put a memory card into the camera with files already on it, numbering will start from the highest number on the existing images.

Auto reset will make the numbers change and go back to 0001 every time you insert a new memory card. Some photographers like this because it allows them to download and organize images in a similar way even though they come from different cards. Manual reset is, as it sounds, a way for you to force the camera to reset its image numbering. When a reset is performed, a new folder is created and the image number begins with 0001.

One curious thing to know about numbering with the 50D is that if you reach 9999 in folder 999, the LCD panel and viewfinder will display a *FuLL* warning. At this point you cannot record new images to that card, even if it has space. You have to go to a new memory card. If you know you are reaching high numbers with your camera, you may want to be sure you use Manual reset before you do any important shooting.

Folders for images on your memory card can be changed in order to allow you to better manage a shoot. Folders are created by going to \P^{\bullet} , scrolling to Select folder and pressing \P^{\bullet} . On the next screen, use the \P^{\bullet} to scroll to Create folder and press \P^{\bullet} . Use the \P^{\bullet} to select OK and press \P^{\bullet} again. A new folder is created with one number higher than your last folder in that memory card.

To select a folder, use the same *Select folder* option. Use the \bigcirc to select the folder you want then press $^{\{gr)}$. Using different folders can be a useful way of separating images as you are photographing.

You can also quite easily add folders with more specific names by using your computer. Put your memory card into a card reader and open it into your computer with Finder in Mac or Windows Explorer in Windows. Add a new folder. Rename the folder using the following convention: 100ABC_D where 100 can be any number from 100-999 and ABC_D can be any combination of letters, numbers, and an underscore. Folders do need to have different digits for the first three numbers.

The nenu includes several output and storage options. The Protect images function, for example, allows you to protect specific pictures from accidental deletion.

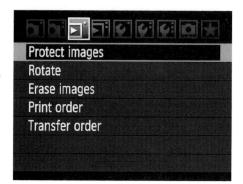

Protect Images

This underused and underappreciated feature can really help you. The most important function of image protection is to allow you to go through your pictures one at a time on the LCD monitor, choosing which ones to keep (protect), so that you can discard all the rest by erasing them all at once.

The Protect images function is very easy to use. Go to Playback 1 Menu and select *Protect images*. Press and one image will appear in the LCD monitor with a symbol of a key and the word SET appearing at the top left of the photo. Next go through your photos one by one using the and push for every one that is a potential keeper. The key icon will now show at the bottom of the image.

Once you have selected the images to protect, erase the rest by selecting *All* on the Erase screen (see below). You have now done a quick edit, leaving fewer photos to deal with after downloading to the computer. There is often downtime when shooting, so use it to go through your photos to protect key shots.

You can also use this protect function when you realize that you have a memory card in your camera that has not been downloaded, yet you need additional storage space. Simply go through the old pictures and protect the ones that you really want to keep, then erase the rest to give you more space on your card.

Erasing Images

The 50D's process for erasing photos from the memory card is the same as that used by most digital cameras. When an image is displayed on the LCD monitor in Playback, push the button located on back of the camera below the LCD monitor. A screen will appear with two options: Cancel or Erase. Turn the to highlight the appropriate choice, then press cancel will cancel this function. Erase will erase the image being displayed. You can erase images during Playback or right after exposure when a photo appears in review.

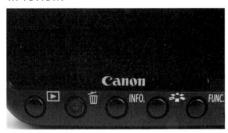

The easiest way to erase images is by using the fine button below the LCD screen.

You can also erase by selecting *Erase images* in This control offers flexibility in how to delete images: *Select and erase images* (which deletes files one at a time, but you don't have to keep pressing the button to go through them), *All images in folder* (which erases only the unprotected images in a particular folder), and *All images on card* (which erases all images except those that are protected).

Note: Once an image is erased, it is gone and not easily recovered (there is software available that may be able to recover it if you don't take any more photos that might record over the original files). Make sure you no longer want an image before making the decision to erase it.

Slide Shows from the Camera

It can be fun to play back photos from the memory card as a slide show on the 50D's LCD (and you can also display a slide show on a television screen, as described in the next section). Start by going to **D**: , then scrolling to Slide show.

Press end you will see a screen that lets you set up how your slideshow will work. You can select all images to play, a folder of images to play, or you can limit images to a particular shooting date for playback in the slide show. A slide show using less than all the images on a card is a little confusing, so we'll start with the *All images* option first. This displays immediately when you select *Slide show*. *Start* is highlighted at the bottom of the screen and you can simply press end to start a slide show.

You can change how the images show as slides by scrolling to $Set\ up$ and pressing $^{\text{gp}}$. Then you can change how long the images stay on the screen by adjusting the sub option for $Play\ time$. Press $^{\text{gp}}$ and you can choose a display time from one to five seconds.

The other set up option is *Repeat* which simply means that your slideshow will continue to repeat from the beginning (*On*), or it stops at the end (*Off*).

Note: You can always move to a previous menu screen by pressing $\blacksquare\blacksquare\blacksquare\blacksquare$.

To run images found in a folder or on a particular date, go to the first Slide show set-up screen. Use the to select All images, then press to go between All images, Folder, and Date. When Folder or Date are chosen, INFO is highlighted—press the INFO. button below the LCD. This brings up a new screen that shows which pictures you can choose. Select the images by scrolling with the and confirming with the button, then use the controls for Set up as described above.

TV Playback

You can display images from the memory card on your TV if you have a set with standard RCA input connectors. You need to be sure you have the right cable, which is the one supplied by Canon. Other cables may not work. Go to Setup 2 Menu ** and be sure the right video system is selected. If you are in the US or Canada, choose NTSC. (For many other parts of the world, you will need to select PAL). Make sure both the camera and television are turned off, then connect the camera to the TV using the cables supplied with the camera. Plug into the Video Out connector on the camera (beneath terminal cover on left side of camera) and Video In on the television. Turn the TV on, then the camera. Now press the button and the image will appear on the TV (but not on the back of the camera). Some TV's will cut off edges of the image.

While standard TV playback worked with earlier models, the images could be disappointing because standard resolution is so low. High-definition television has encouraged a lot of people to buy large screens because the resolution is so high and TV shows look very good on it. High-definition TV also looks great for displaying your photographs, especially on large screens.

To display images from the 50D on a high-definition TV, you will need to buy Canon's HDMI Cable HTC-100. (The camera does have the HDMI fitting built into it, but doesn't come with the cable.) Connect this cable to the HDMI Out port beneath the terminal cover on the left side of the camera, then the other end of the cable to HDMI In on the television set. Then turn on the TV and camera, then press the button on the camera. Be sure to select the correct TV port so that the cameras images display on the TV.

Note: You cannot use the video and HDMI ports at the same time on the camera.

Camera Operation Modes

Clearly, the EOS 50D continues Canon's tradition of creating highly sophisticated and versatile digital cameras at an affordable price. Innovation and technology come together for the 50D in ways that become evident as soon as you begin to operate its various systems and utilize its many functions. From finding focus on moving subjects to shooting multiple frames per second to metering and capturing great exposures in low light, the 50D offers a number of options to help you take extraordinary photographs.

Focus

The 50D's nine-point AF system is the same as in the 40D, which was an improved method that evolved from the 30D. The actual position of sensor points was well chosen in the 30D, so this is not much changed. However, the AF sensor itself was newly developed for the 40D with improved AF detection, precision, and accuracy.

All nine AF points are sensitive to both horizontal and vertical lines with lenses that have maximum apertures as small as f/5.6. In addition, the center point has enhanced precision in both directions with lenses having maximum apertures of f/2.8 or faster. This is a very high performance AF system for this level of camera. It's actually better than previous Canon systems because the auxiliary array for the center point has a diagonal orientation that enhances precision in all directions. Even if subject contrast happens to be parallel to one of the lines, the other one will pick it up.

Deep focus was achieved in this image by using a wide-angle lens and a small f-stop, and by setting the key point of focus about one third of the way into the scene. **Insider View:** Autofocus technology is pretty amazing and really way beyond the scope of a book like this. AF works by detecting contrast, so having a system that gives it more opportunities to detect that contrast will increase its precision and accuracy.

To further refine its performance, the AF unit has precise AF optics and environment-resistant construction and materials to keep autofocus consistent in all conditions. Unwanted light is blocked both by a narrow field-of-view and by low-reflectance materials built into the sensor area.

The AF points work with an Ev (exposure value) range of 0.5–18 (at ISO 100) and are superimposed in the viewfinder. They can be used automatically (the camera selects them as needed), or you can choose one manually. AF modes are selected by the photographer and include **ONE SHOT** AF, **AI SERVO** AF, and **AI FOCUS** AF. Manual focusing is also an option.

The 50D smartly handles various functions of autofocus through the use of a high-performance, 32-bit microprocessor. It has the ability to quickly employ statistical prediction while using multiple focusing operations to follow even an erratically moving subject. Yet, if the subject is not moving, the Al SERVO AF focus control will not allow the lens to change focus until the subject moves again.

When light levels are low, the camera activates AF-assist with the built-in flash if it is popped up (external dedicated flashes also will do this). It produces a series of quick flashes to help autofocus. The range extends to approximately 13 feet (4 meters) in the center of the frame and 11.5 feet (3.5 m) at the other AF points. The 580EX Speedlite includes a more powerful AF-assist beam that is effective to 33 feet (10.1 m).

AF Modes

The camera has three AF modes in addition to Manual focus: (1) **ONE SHOT** AF (AF stops and locks when focus is achieved, one shot at a time); (2) **AI SERVO** AF (this tracks subject movement and focuses continuously until the exposure is made); and (3) **AI FOCUS** AF (the camera switches automatically between **ONE SHOT** and Servo as it detects movement of the subject). In the Basic Zone shooting mode, one of two major groups or categories of the shooting modes found on the Mode Dial, the AF mode is set automatically. In the Creative Zone, the other group of shooting modes (see pages 152-167 for discussion of shooting modes), you can choose among all three AF modes; they are accessed by pressing the AF•DRIVE button located on the top right of the camera in front of the LCD panel. Use the Main Dial to scroll in the LCD panel to the mode you want to use.

A quick note about manual focus (MF) and AF: On Canon cameras, the change between AF and MF is done with a switch on the lens and has nothing to do with the AF functions that the camera controls. If MF is chosen on the lens, then no AF is possible. For autofocus to work, you must choose AF on the lens.

ONE SHOT AF: This AF mode finds and locks focus when you press the shutter button halfway (exposure is also set). This is perfect for stationary subjects. It allows you to find focus and hold it at the important part of a subject. If the camera doesn't hit the right spot, it is a simple and quick matter to slightly change the framing and press the shutter button halfway again to lock focus. Once you have found and locked focus (the focus confirmation light will glow steadily in the viewfinder—it will blink when the camera can't achieve focus), you can then move the camera to set the proper composition. Since this camera focuses very quickly, a blinking light is a quick reminder that you need to change something (you may need to focus manually or you might be too close to the subject for the lens to focus).

AI FOCUS AF: This mode allows the camera to choose between **ONE SHOT** and **AI SERVO** AF modes. It was designed to be used as a standard setting for the camera because it switches automatically from **ONE SHOT** to **AI SERVO** if your subject starts to move. Note, however, that if the subject is still (like a landscape), this mode might detect other movement (such as a blowing tree), so it may not lock on the non-moving subject.

Insider View: I am not fond of this mode. I find that it consistently changes out of the mode I need to the mode I don't want, and focus is off. I recommend making a distinct choice of either **ONE SHOT** or **AI SERVO** AF for each specific situation. That way you will know what to expect (especially after a little experience shooting with specific settings).

AI SERVO AF: A great option for action photography where subjects are in motion, AI SERVO becomes active when you press the shutter button down halfway, but it does not lock focus. It continually looks for the best focus as either you move the camera or as the subject travels through the frame. It is really designed for moving subjects, since both the focus and exposure are set only at the moment of exposure. This can be a problem to use for motionless subjects because the focus will continually change, especially if you are hand-holding the camera (the camera will interpret the movement in the image area due to your hand-holding as movement of the subject and will sometimes change focus arbitrarily). However, if you are using AI SERVO AF on a moving subject, it is a good idea to start the camera focusing (depressing the shutter button) before you actually need to take the shot so that the system can find the subject.

Selecting an AF Point

You can have the camera select the AF point automatically, or you can use the Multi-controller to manually select a desired point. Manual AF point selection is useful when you have a specific composition in mind and the camera won't focus consistently where you want. To manually select an AF point, simply push the AF point button (on

back of the camera at the upper right) and move the Multicontroller in any direction to select a focus point. The points light up as they are selected (they also appear in the LCD panel on the top of the camera). If you push the controller to an already lit point, the camera automatically selects them all. Pressing in the center of the Multi-controller will automatically select the center point. It is an intuitive control that is simple to use. You can also go back to auto AF point selection quickly by pressing the Multi-controller twice in any direction. It is possible to use the Quick Control Dial to move through all the AF points, but this is much slower because you have to circulate through each point, one at a time.

The AF point can be set automatically or you can choose one manually.

AF with Live View

Autofocus is a little different when using Live View. This has also been changed since the 40D. You do not get the three types of AF that the camera uses normally. The three modes available for Live View AF are Quick mode, Live mode, and Live (face detection) mode. Of course, you can always focus manually as well. It is important to note that these modes must be chosen before you try to autofocus. These are chosen in Set-up Menu 2 under Live View function settings, AF mode as described on pages 99-103. Or, once the camera is in Live View mode and the Live image is displayed on the screen, you can select the AF mode using the AF•DRIVE button and the Main Dial constant to select among the icons that appear along the bottom of the LCD screen. That said, you can use the

Multi-controller to change between Live mode and Live mode when Live mode is set from the menu. Press the Multi-controller straight down to make this change.

Quick mode: Quick mode is a one-shot type of autofocusing that is very similar to the standard **ONE SHOT** AF. It uses the AF sensor built into the viewfinder area, just like the other AF modes of the camera. Press the AF-ON button to focus. However, to do this, the camera must drop the mirror briefly so that that AF sensor can look through the lens; this results in a brief blackout of the Live View image. This is a fast and accurate way of using AF.

Live mode: Live mode is also a one-shot type of autofocusing. This AF uses the image sensor itself for AF. Press the AF-ON button to focus. Since the image sensor is not actually designed for this purpose, the camera has to do some rather complex processing of the image in order to find focus. That can mean that the focusing is slower and not necessarily as precise as it is in Quick mode, but the Live View image never disappears from the LCD during focusing.

Live : mode: Live : mode, like the Quick and Live modes, is a one-shot type of autofocusing. Press the AF-ON button to focus. This works exactly the same as Live mode, except that the camera adds another level of processing to the way it looks for focus. In this case, it looks for faces. When it recognizes a face, the camera shifts the autofocus point to that face and focuses there. Face detection does not work if a face is very small or very large, poorly exposed, tilted away from vertical, or at the edge of the image frame.

Magnifying the image for focusing in Live Mode: The 50D allows you to magnify a portion of the image when you are shooting in Live Mode so that you can better see where your focus is. This works in both AF and MF. To magnify the image, press the AF point selection button at the upper right corner of the back of the camera when you are in Live View. Press it once for a moderate, 5X magnification, a second time for a stronger, 10X magnification, and a third time to

put the LCD back to normal view. Use the Multi-controller to move the focusing box around the image; a small white outline appears, showing you where the focusing box is in relationship to the entire frame.

Insider View: This magnification feature is really a great addition to the 50D's Live View. It works really well when you are shooting close-ups from a tripod, as you can check the exact focus quite well as you move the magnify-focus box around the image area with the Multi-controller.

AF Limitations

AF sensitivity is high with this camera. Still, as the maximum aperture of lenses decreases, or tele-extenders are used, the camera's AF capabilities may be severely reduced. It is important to realize that this is normal and not a problem with the camera. Full function of the 50D's cross-type AF points (that recognize horizontal and vertical lines) occurs at f/5.6 or larger f/stops (f/4, f/2.8, and so forth).

Autofocus may fail in certain situations, therefore requiring you to focus manually. This would be most common where the scene is low-contrast or has a continuous tone (such as sky), in conditions of extremely low light, with subjects that are strongly backlit, and with compositions that contain repetitive patterns. A quick and easy way of dealing with these situations is to move the camera to focus on something at the same distance as the rest of the photo, lock focus on it, then move the framing back to the original composition.

AF-ON Button

For many years, sports photographers would use a camera's Custom Functions to set up one of the back buttons to act as an AF-start button. This would allow them to use their thumb to activate autofocus when the action got intense. This avoided the problem of using the shutter button, because pressing it halfway to start AF also made it too easy to take an unwanted picture and could cause exposure problems due to the AF- and AE-lock functions. While digital has no direct cost to shooting extra shots, having the camera go off

Using the AF-ON button instead of the shutter button lets you start autofocusing without affecting any other control, such as autoexposure.

inappropriately would often throw off the shooting rhythm of an action photographer, hence the need for a button to easily allow focus—and only focus. The AF-ON button does exactly that, turning on AF without requiring you to touch the shutter release button.

Drive Modes and the Self-Timer Control

The 50D offers three drive modes—Single shooting (\square , one image at a time), High-speed continuous shooting (\square +, 6.3 frames per second), and Low-speed continuous shooting (\square +, 3 fps). One advantage of the Low-speed continuous mode is that you can shoot continuously for a longer time period before the camera stops due to a full buffer—this can be especially important when shooting RAW. There are also options for 2-second and 10-second self-timers. They can be used in any situation where you need a delay between the time you press the shutter button and when the camera actually fires.

AF options and Drive modes, including self-timer modes, are set with the AF-DRIVE button in combination with either the Main Dial arr or the Quick Control Dial .

All drive modes are selected by pressing the AF-Drive button located in the row of buttons on the top right of the camera in front of the LCD panel. Then rotate the Quick Control Dial to cycle through a display in the panel for each of the drive icons.

Insider View: A self-timer can be very helpful when you are shooting slow shutter speeds on a tripod and can't (or don't want to) use a cable release. I used to use the 10-second delay all the time with earlier cameras in this series, but that sometimes was longer than I wanted. It did, however, allow camera vibrations to settle down before the shutter went off. You really only need a couple of seconds for this, though, hence the addition of the 2-second delay.

Exposure

No matter what technology is used to create a photo, good exposure is important. Digital photography is no exception. A properly exposed digital file is one in which the right amount of light has reached the camera's sensor and produces an image that corresponds to the scene, or to the photographer's interpretation of the scene. This applies to color reproduction, as well as tonal values and subject contrast.

Insider View: Photographers who take the attitude that they will "fix it in Photoshop" are really not using their camera to its best ability, plus they are making more work for themselves in the computer. The more you have to fix an image in Photoshop, the less likely the picture is going to be at its best quality, plus you're going to be spending a lot of extra time at the computer than you really need to.

ISO Sensitivity

The first step in getting the best exposure with any type of camera has always been choosing the ISO speed. This provides the meter with information on the film's sensitivity to light, so that it can determine how much exposure is required to record the image. Digital cameras adjust the sensitivity of the sensor circuits to settings that can be compared to film of the same ISO speed. (This change in sensitivity involves amplifying the electronic sensor data that creates the image.)

The 50D offers ISO sensitivity settings within a range of 100–3200, plus Auto, but can also be set to expand to ISO 6400 and 12,800. This full ISO range is only available in the Creative Zone (see pages 158-164). In the Basic Zone shooting modes (see pages 154-157), ISO is set automatically from 100-1600. ISO speed can be set from ISO 100 to ISO 1600 in 1/3- or 1-stop increments, and can be viewed on both the LCD panel and in the viewfinder.

Low ISO settings give the least amount of noise, highest quality, and the best color. Some increase in noise (the digital equivalent of grain) will be noticed as the higher ISO settings are used, but it is usually acceptably low even at ISO 800 and 1600, though added noise may be a problem if the scene is underexposed. On the other hand, a low ISO means slower shutter speeds that can result in unsharp images because of subject or camera movement. Some noise is generally preferable to blurry photos.

When you need them, the settings of 800 and 1600 offer good results. This opens your digital photography to new

possibilities for using slow lenses (lenses with smaller maximum lens openings, which are usually physically smaller as well) and for shooting with natural light.

Insider View: ISO is one control worth knowing so well that its use becomes intuitive. Its speed can be quickly set in the Creative Zone. Since sensitivity to light is easily adjustable using a D-SLR, and since the 50D offers clean images with minimal to no noise at any standard setting, ISO is a control to use freely so you can adapt rapidly to changing light conditions. You could choose Auto, but I don't recommend that. It is best to know what you are setting so that you are making an educated choice about noise and sharpness issues.

Setting the ISO: To set the ISO speed, press the ISO·22 button located on the top right of the camera in front of the LCD panel. Then turn the Main Dial until you see the desired ISO displayed in the LCD panel. The ISO settings occur in either 1/3- or 1-stop increments (chosen by Custom Function I-2—see page 106). Most photographers will find the 1-stop increments are easier to use.

Several key ISO settings are important to remember and choose: 100 to capture detail in images of nature, land-scape, and architecture in bright ambient light or when using a tripod; 400 when more speed is needed, such as hand-holding for portraits when shooting with a telephoto lens; and 800 and 1600 when you really need a lot of speed under low-light conditions.

A, or Auto, ISO uses 400 as its base and changes it up or down from 100-1600 in order to keep shutter speed high and reduce blur due to camera movement. However, even on A, ISO is fixed at 100 for the Portrait mode, 400 for Manual (M) exposure, and 400 for flash.

The camera also has a high ISO setting of 3200 and special options of 6400 and 12,800. Canon offers the latter as a specialized choice, available as Custom Function (C.Fn) I-3 (ISO expansion, see page 106). The high speed of 3200 is

distinctly noisier than lower settings, but if you are in a situation that requires such speed, the camera will give it to you. With *ISO* expansion set to *On*, 6400 and 12,800 are added to the ISO choices. However, they are designated by "H1" or "H2," respectively, in the LCD panel, not as the numbers "6400" or "12,800."

Insider View: If you regularly need ISO 6400 or 12,800—say you do indoor sports photography—then consider putting the Custom Function access into My Menu ★ . Unless you really need those high ISOs, however, I would avoid them altogether by not having them easily available. There is a lot of noise in the images and they are very highly processed by the camera, which tends to make fine details in the image look a little mushy.

High ISO Noise Reduction: High ISO noise reduction (C.Fn II-2, see page 110) can be used for images taken at high ISO speeds and is based on technology developed with the EOS-1D Mark III. Although the camera applies some noise reduction to the image at all ISO speeds by default, this option is particularly effective at high ISOs. In fact, even at lower speeds, choosing one of the noise reduction levels may further reduce noise in shadow areas.

Insider View: High ISO noise reduction is a helpful feature that can bring out the very maximum in image quality from the 50D. Shadows can sometimes exhibit noise if you brighten them significantly in the computer, so this can help. On the other hand, you will not be able to shoot continuously for long bursts of action when it is enabled. You can, however, turn it off if you run into those conditions. Generally speaking, the cost in terms of quality loss is low for the benefit if you need it, although you may find that it adversely affects certain images with a lot of fine detail.

Metering

In order to produce the proper exposure, the camera's metering system has to evaluate the light. However, even in today's environment of rapid photo technology advances, no existing light meter will produce a perfect exposure in every situation. Because of that, the 50D does not simply have an exposure meter – it has a rather highly evolved metering system inside the camera. The camera's metering system has been designed with microprocessors and special sensors that give the system optimum flexibility and accuracy in determining exposure.

Insider View: At one time, I exclusively shot Manual exposure and always thought I could do better than automatic. When I started as a journalist covering the photo industry for photographers, I thought I should understand autoexposure better and at least try using it. I now shoot using it about 95% of the time and get great exposures. Modern cameras with their multi-point metering systems and intelligent interpretation of exposure really do a great job. You do still have to know a bit about exposure, however, so you can help the meter do its best job.

• Evaluative Metering: The 50D's Evaluative metering system divides the image area into 35 zones. As with all Canon EOS cameras, the 50D's Evaluative metering system is linked to the autofocus points. The camera actually notes which autofocus point is active and emphasizes the corresponding metering zones in its evaluation of the overall exposure. If the system detects a significant difference between the main point of focus and

Many major camera controls, such as metering mode, white balance, ISO, and flash exposure compensation, are set with the buttons in front of the top LCD panel.

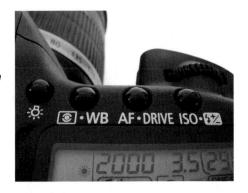

the areas that surround this point, the camera automatically applies exposure compensation (it assumes the scene includes a backlit or spot-lit subject). However, if the area around the focus point is very bright or dark, the metering can be thrown off and the camera may underexpose or overexpose the image.

Insider View: Extremely dark or light subjects, subjects with unusual reflectance, or backlit subjects can be challenging for any meter, including the sophisticated Evaluative Metering. Meters base their analysis of light on an average gray scene, so when subjects or the scene differ greatly from average gray, the meter will tend to overexpose or underexpose them in order to "make" them gray. Check the image on the LCD monitor (though realize that it may display light or dark—you can learn that from experience). Also review the histogram and blinking Highlight alert and, if you are still able, reshoot if required. The 50D offers a great deal of information, so use it all to help you in these situations.

Evaluative metering looks at 35 different parts of the photograph, compares brightness values, then computes an exposure for the scene.

The main advantage of Evaluative metering over Partial . Spot . and Center-weighted average metering is that the exposure is based on a comparative analysis of multiple metering points in a scene and is biased toward the active AF point, rather than just concentrating on the center of the picture.

• Partial Metering: Partial metering covers about 9% of the frame, utilizing the exposure zones at the center of the viewfinder. This allows you to selectively meter portions of a scene and compare the readings in order to select the right overall exposure. This can be an extremely accurate way of metering, but it does require some experience to do it well. When shooting with a telephoto lens, Partial metering acts like Spot metering ...

- Spot Metering: This mode restricts the metering to a central 3.5% (approximate) of the viewfinder, which allows you to selectively meter a scene even more than Partial metering does, such as accurately metering a spot-lit subject surrounded by totally different light than what illuminates the subject itself. Like Partial Metering, Spot metering does require some practice to master.
- Center-Weighted Average Metering: This method averages the reading taken across the entire scene, but in computing the average exposure, the camera puts extra emphasis on the reading taken from center of the horizontal frame. Most early traditional SLR cameras used this method exclusively, so some photographers prefer sticking with it.

Be aware that exposure is affected by an open viewfinder eyepiece. If you are shooting a long exposure on a tripod, and do not have your eye to the eyepiece, there is a good possibility that your photo will be underexposed (the meter sensors are in the viewfinder area and can be influenced by light coming in from the eyepiece). To prevent this, Canon has included an eyepiece cover on the camera strap that can be slipped over the viewfinder to block the opening in these circumstances.

Judging Exposure

The LCD monitor allows you to get an idea of your photo's exposure—it's sort of like using a Polaroid as a test photo, although it isn't as accurate. However, with a little practice, you can use this small image to evaluate your desired exposure, as long as you realize that it is to be used only as a rough guide, and isn't accurate enough to show you exactly what you will see when the images are downloaded into your computer (because of the monitor's calibration, size, and resolution). The relatively high-resolution of the 50D's LCD does allow you to better evaluate how highlights and shadows are being rendered by an exposure.

Insider View: Some people will tell you that you can't use the monitor to analyze exposure or color because of its inaccuracies (though with every model, the LCD gets better). You can't use the monitor as an exact indication of the final photo, but you can learn to evaluate it. You need to know if it reads bright or dark (and this will vary from camera body to camera body, even in the same model of camera). Do this by shooting some test shots, noting how they look in the LCD, then immediately downloading them to your computer, or have them printed if you don't work with a computer. Then compare how the images look on your computer monitor or as prints with what the LCD shows.

The EOS 50D includes two features that give good indications as to whether or not each exposure is correct. These features, the Highlight alert and the histogram, can be seen on the LCD monitor once an image is displayed there. Push the INFO. button (on back of the camera below the LCD) repeatedly to cycle through a series of four displays: two that show the image along with exposure information, a small photo showing the Highlight alert along with the brightness histogram and exposure information, and the fourth shows the Highlight alert along with RGB histograms, the brightness histogram, and exposure information.

Highlight Alert: The camera's Highlight alert is very straightforward: Overexposed highlight areas will blink on the photos displayed on your LCD (you can turn this off in Playback Menu 2). These areas have so much exposure that only white is recorded—no detail. It is helpful to immediately see what highlights are getting blown out, but some photographers find the blinking to be a distraction. Blinking highlights are simply information, and not necessarily bad. Some scenes have less important areas that will get washed out if the most important parts of the scene are exposed correctly. However, if you discover that significant parts of your subject are blinking, the image is likely overexposed. In this case, you need to reduce exposure in some way.

Understanding how to use the histogram can help you get the best exposure on a whole variety of scenes, but especially when the light is strong and contrasty.

Insider View: Avoid reducing your exposure too much. Some photographers want to avoid blown-out highlights to the point that there are no blinking highlights. They figure if they have none, they are safe. This can lead to seriously underexposed images and can cause noise problems. I recommend you adjust exposure until the blinking just turns off over important highlights, but no further.

The Histogram: The histogram is an important tool for digital photographers, and is the graph that appears on the LCD monitor next to the image when you press the INFO. button during image review or playback, indicating the image's brightness levels from dark to light. The 50D gives a choice between the standard brightness, or luminance, histogram and a set of RGB histograms. To select between these, you must continue cycling through the screens by pressing INFO. For most photographers, brightness is best.

The RGB histograms are harder to interpret and really are of most use to commercial photographers who have very specific color balance needs.

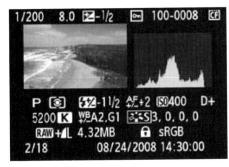

One of the four different LCD displays accessible via the INFO. button shows a small image along with a luminance histogram.

The horizontal axis of the all histograms indicates the level of brightness—dark areas are at the left, bright areas are at the right. The vertical axis indicates the pixel quantity existing for the different levels of brightness. For RGB histograms, you are seeing levels of brightness for specific color channels (red, green, and blue).

Insider View: It is important to understand that there is no specific correct shape for a histogram. A histogram's shape is dependent upon the relative amounts of dark, midtone, and bright areas of the picture. For example, a picture that had a lot of dark areas and some bright areas but no real middle tones would have a histogram that had a peak on the left for the dark areas and a smaller one on the right for the bright areas. A picture that has a lot of middle tones might have a shape that's like a little hill where it is low on the left and right and high in the middle.

What you need to look for in a histogram is how the right and left sides look. If the graph rises as a slope from the bottom left corner of the histogram, then it has any sort of shape toward the middle, but finally descends towards and reaches the bottom just before the right corner, all the tones of the scene are captured. The key is those slopes at left and right.

If the graph starts high on the left and looks like it is abruptly cut off, or it ends high on the right and is abruptly cut off, then the exposure data is also cut off, or "clipped," at the ends because the sensor is incapable of handling the areas darker or brighter than those points. No detail will be recorded at the clipped side, whether in the shadows or the highlights. In addition, the histogram may be weighted towards either the dark or bright side of the graph (wider, higher "hills" appear on one side or the other). This is okay if the subject is mostly dark or bright, but if it is not, detail may be lost. The dark sections of your photo may fade to black (with increased noise there), and brighter sections may appear completely washed out.

If highlights are important, be sure that the slope on the right reaches the bottom of the graph before it hits the right vertical axis, but without a significant gap at the right side, either. If darker areas are important, be sure the slope on the left reaches the bottom before it hits the left axis. I deliberately used this order, talking about the right side first. Clipping on the right side can be a real problem—we accept photographs that have dark areas in the picture that can't be fully seen, but washed out bright areas of the picture are usually distracting. The right side of your histogram is all about those bright highlights.

You don't actually have to remember which side is dark or light at first. If you notice an unbalanced graph, just give the scene a change of exposure and notice which way the histogram changes. This is a really good way to learn to read the histogram.

If the scene is low in contrast and the histogram is a rather narrow hill in the middle of the graph, check the 50D's Picture Style settings. Boosting contrast will expand the histogram—you can create a custom setting with contrast change and tonal curve adjustments that will consistently address such a situation. This can mean better information being captured since it is spread out more evenly across the tones before bringing the image into your computer to use

image-processing software. In addition, this type of histogram is a good condition for using RAW, since the stretching of data to better use the tonal range from dark to light looks best in RAW.

Highlight Tone Priority

The 40D added a neat little feature that many people might have missed and is included in the 50D too: Highlight Tone Priority. One of the challenges that digital cameras have always had is the way they deal with highlights, especially when shooting JPEG. By applying Highlight Tone Priority, the camera's internal processor works to improve highlight detail in a photo. It extends the range of tones from middle gray to the maximum highlight tone so that more gradations of tone are registered in the image. This gives finer gradations and reduces the chance of blown-out highlights. This does not have any effect in RAW files, but is actually using RAW file data to gain better highlight detail. The function is limited to ISO 200-3200. It is set in C.Fn II-3 (see page 110).

* AE Lock

AE lock is a very useful tool in the Autoexposure modes. Under normal operation, the camera continually updates exposure either as you move the camera across the scene or as the subject moves. This can be a problem if the light across the area is inconsistent yet remains constant on the subject. This feature allows you to lock the exposure on that subject and its light. This tool is also helpful when a scene is mostly in one light, yet your subject is in another. In that circumstance, try to find a spot nearby that has the same light as your subject, point the camera at it and lock exposure, then move the camera back to the original composition.

AE lock on the 50D is similar to that used for most EOS cameras. Its button is located on the back of the camera to the upper right and marked with \mathbf{x} .

To use AE lock, aim the camera where you need proper exposure, then push $\begin{tabular}{l} \bigstar \end{array}$. The exposure will be locked on that spot even if you move the camera and $\begin{tabular}{l} \bigstar \end{array}$ will

appear in the viewfinder's information display. The exposure scale on the right side gives important data—it compares the locked exposure in the center with the "present exposure" of the composition (the second dot). If you don't like what the lock gave for exposure, you can change it by pressing **again. You can also shift exposure by using the Main Dial **or apply a degree of compensation with the Quick Control Dial **O.

Exposure Compensation

The existence of a feature for exposure compensation, along with the ability to review images in the LCD monitor, means you can quickly get good exposures with any Autoexposure mode. Exposure compensation cannot be used in Manual Exposure **M** mode. However, it makes the **P**, **Tv**, **Av**, and **A-DEP** modes much more versatile. Compensation is added (for brighter exposure) or subtracted (for darker exposure) in increments of 1/3 or 1/2 stops (you set this in C.Fn I-1; see page 106) up to +/- 2 stops.

It only works if the camera's metering system is active (enable by depressing shutter button halfway to see both shutter speed and aperture in the viewfinder's information display) and can be adjusted quite easily when the power switch is set to the upper mark () and by rotating the Quick Control () with your thumb. The exact exposure compensation amount will display on the viewfinder as well as on the LCD panel.

It is important to remember that once you set exposure compensation, it stays set even if you shut off the camera. Regularly check your exposure setting (by looking at the bottom scale in the viewfinder information display) when you turn on your camera to be sure the compensation is not inadvertently set for a scene that doesn't need it.

Insider View: With experience, you will find that you use exposure compensation regularly. Canon makes this very easy to do with the Quick Control Dial . Remember, the meter wants to increase exposure on dark subjects, so use exposure compensation to decrease exposure for them. The meter wants to decrease exposure on light subjects to make them closer to middle gray, so use exposure compensation to increase exposure for them. Don't forget how valuable the LCD monitor is when experimenting with exposure compensation. Take a test shot and check the photo and its histogram. If the histogram looks good, go with it. If the scene is too bright, subtract exposure; if it's too dark, add it. Again, remember that if you want to return to making exposures without using compensation, you must move the setting back to zero!

Autoexposure Bracketing (AEB)

Autoexposure bracketing (AEB) is another way to apply exposure compensation, but this time in a semi-automatic fashion. AEB tells the camera to make three consecutive exposures that are different: (1) A standard exposure (it will use your existing camera settings, including exposure compensation as this standard); (2) one with less exposure; and (3) one with more (this sequence can be changed with C.Fn I-5, see page 107). The difference between exposures can be set up to +/- 2 stops in stop increments of 1/3 (C.Fn I-1 will allow you to change this to 1/2-stop increments, see page 106). AEB is set through Scroll to Expo. Comp./AEB and press the Main Dial to set the amount. Three dots will appear on a small exposure scale on this menu (they will also appear on the LCD panel). These indicate the range of exposures.

As you shoot, you will also see a marker appear on the exposure scale in the display at the bottom of the viewfinder. This marker indicates which exposure is being used with the AEB sequence. When in \Box drive mode, you must press the shutter button for each of the three shots. In the continuous shooting modes, the camera will take the three shots and stop. In the Self-timer modes, all three shots will be taken.

While utilizing AEB, the 50D will change aperture in **Tv** mode (keeping your chosen shutter speed constant) and shutter speed in **Av** mode (keeping your chosen f/stop constant). If you use AEB, remember that the camera will continue to take three different exposures in a row until you cancel the setting, turn the camera off, or change lenses.

Insider View: AEB can help ensure that you get the best possible image files for later adjustment using image-processing software. A dark original file always has the potential for increased noise as it is adjusted, and a light image may lose important detail in the highlights. AEB can help you to determine the best exposure for the situation. You won't use it all the time, but it can be very useful when the light in the scene varies in contrast or is complex in its dark and light values. AEB is also important for a special digital editing technique that allows you to put multiple exposures together into one master to gain more tonal range from a scene or something called HDR. With HDR, you can take a series of photos—with your 50D, this works well with AEB set to 2 stops. Set the camera to one of the continuous shooting drives—the camera will then take the three photos for the AEB sequence and stop. Now you use a program such as (www.hdrsoft.com) Essential or (www.imagingluminary.com) to combine those three pictures. These programs take the best tonalities from each exposure and combine them into one image so that you get a picture that includes a tonal range far greater than the camera is actually capable of doing on its own.

Shooting Modes

The 50D offers thirteen shooting modes (sometimes called exposure modes) divided into two groups: the Basic and the Creative Zones. These all appear on the Mode Dial at the upper left of the camera. The Basic Zone starts at A and goes clockwise for eight options. The Creative Zone starts at the letter P and goes counterclockwise to A-DEP. In addition, there are two user-set modes, C1 and C2.

In the Basic Zone, the camera automatically chooses exposure settings for specific conditions or to a subject. Fast and easy to manage, the modes in the Basic Zone instruct the camera to predetermine a number of settings. Exposure, ISO, and white balance are set automatically in all Basic Zone modes, while the metering method is Evaluative. In most of these modes, all the controls are set by the camera and cannot be adjusted manually. In addition, the Auto Lighting Optimizer feature of the camera is always on.

In the Creative Zone, settings can be chosen and adjusted by the photographer in order to better control his or her photography.

Insider View: The Basic Zones do work, and offer many photographers a quick and easy way of making decisions about camera setup—you don't have to make any decision except which shooting mode to choose. However, such modes will limit the advanced photographer because they may not be perfectly appropriate for the needs of a given photographer and his or her approach to the subject.

All shooting modes, including the Basic Zone modes, are selected by using the Mode Dial on the left top of the camera. Simply rotate the dial to the icon that represents the mode you wish to use. In the Basic Zone, ISO setting is

The Creative Zone modes start at P and go counter-clockwise on the Mode Dial. These modes offer you varying degrees of control, ranging from semi-automatic to fully manual. Basic Zone modes provide more automatic settings and start at CA and go clockwise around the dial.

automatic within the range of 100-1600, except for the Portrait setting, which is fixed at 100. In the Creative Zone, you can choose any ISO setting.

Basic Zone Shooting Modes

Full Auto: For completely automatic shooting, this mode essentially converts the 50D into a point-and-shoot camera (though a very sophisticated point-and-shoot!). The camera chooses everything—you cannot adjust any controls. This mode is really designed for the beginning photographer who does not trust his or her decisions, or for situations when you hand the camera to someone to take a picture of you (that way they can't mess up settings).

CR Creative Auto: New to the 50D, this mode takes Full Auto and gives a little control back to the photographer. the LCD. These are selected using the Multi-controller -a short statement about each adjustment appears at the bottom of the LCD to remind you what the control does. They are adjusted with the Quick Control and Main dials, and include the following: flash firing options (Auto flash, Flash on, and Flash off); blurring/sharpening the background (this changes the f/stop of the lens); adjusting picture brightness (this changes exposure compensation); Picture Style (this lets you select one of four Picture Styles— Standard, Portrait, Landscape, or Monochrome-these are explained in detail on pages 71-77); three drive modes (single shot, 3 fps, and self-timer); and image recording quality (JPEG, RAW, or RAW+JPEG). In addition, this screen shows battery power, maximum burst of shots possible, and shots left on the card.

Portrait: If you like to shoot portraits, this makes adjustment choices that favor people photography. The drive is set to the Low-speed continuous drive setting of 3 fps, so you can shoot changing gestures and expressions, while the AF mode is set to **ONE SHOT** so you can lock focus with slight pressure on the shutter release (or use AF-ON). The meter favors wider f/stops (smaller numbers) because this limits

The Portrait mode works well for photographing people because it automatically sets a large aperture, thus blurring the background and separating it visually from the subject.

The Close-Up mode simplifies close-up photography and helps make sharper hand-held photos by setting a faster shutter speed.

depth of field, offering backgrounds that are softer and therefore contrast with the sharper focus of the subject. A wider f/stop also results in faster shutter speeds, resulting in sharper hand-held images, plus the camera chooses the Portrait Picture Style setting for better skin tones (most other Basic Zones use the Standard Picture Style).

Landscape: For a scenic picture, it is important to lock focus one shot at a time, so Landscape mode uses **ONE SHOT** AF and the Single-Shot drive mode. The meter favors small f/stops (large numbers) for more depth of field (often important for scenic shots), plus the camera chooses the more saturated and crisp Landscape Picture Style setting.

- Close-Up: This mode also uses ONE SHOT AF and the Single-Shot drive mode. It favors wider f/stops for faster shutter speeds, giving better sharpness with a hand-held camera, and for less depth of field in order to set a sharp subject off against a softer background.
- Sports: Designed for action and fast shutter speeds to stop that action, this mode uses AI SERVO AF and the High-speed continuous drive mode, both of which allow continuous shooting as action evolves in front of you. In addition, the beep for AF confirmation will be softer than in other modes.
- Night Portrait: Very useful to help even the advanced photographer balance flash with low-light conditions (that do not necessarily have to be night). This uses flash to illuminate the subject (which may or may not be a portrait), then uses an exposure to balance the background, bringing in its detail. The latter exposure, called the ambient light exposure, can have a very slow shutter speed, which may mean a blurry background (which can be very interesting, or just unpleasant), so you may want to use a tripod.
- Flash Off: Provides a quick and easy setting that prevents the flash from firing, which can be important in museums and other sensitive locations.

Auto Brightness and Contrast Correction

When images are processed internally for JPEG files in the Basic Zones, the camera's processor examines the scene and applies some brightness and contrast correction as it thinks it is needed, including using the Auto Lighting Optimizer. With bright scenes, like those shot of snowy conditions, the meter will often cause the photo to be underexposed (it overreacts to the brightness). The Auto Lighting Optimizer compensates for this by making an automatic adjustment to make highlights brighter.

Another common challenge for many photographers occurs when the subject is beyond the distance range of the flash and therefore looks dark. If the camera senses this in

the image, it will apply a correction to make the highlights brighter, making the image look more natural. Another example of this auto correction feature is when the camera detects what it thinks is a hazy, low-contrast scene. Then processing is applied to increase contrast.

Insider View: This really isn't bad for the highly automated Basic Zones, though you should be aware that it can make inaccurate corrections at times because the camera can only analyze data and doesn't see the real scene you see.

Creative Zone Shooting Modes

The Creative Zone modes offer much more control over camera adjustments than the Basic Zone modes, and as a result encourage a more creative approach to photography. The disadvantage is that there are many possible adjustments, a situation that can be confusing, especially for less experienced photographers. Again, all modes in the Creative Zone are engaged by turning the Mode Dial to the desired icon. Adjustments to the settings, which are displayed in the LCD panel and viewfinder, are made by turning the Main Dial

P Program AE Mode: In Program AE (autoexposure), the camera chooses the shutter speed and aperture combination. This gives the photographer less direct control over the exposure than in other Creative modes because the settings are chosen by the camera, not you.

Program AE mode selects shutter speed and aperture values steplessly. This means that any shutter speed or aperture within the range of the camera and lens will be selected, not just those that are the standard full steps, such as 1/250 second or f/16. This has been common with most SLRs (both film and digital) for many years and allows for extremely precise exposure accuracy. You can shift the mode's choices by changing either the selected aperture or shutter speed, and the system will compensate to maintain the same exposure value. To shift Program, simply press the shutter button halfway, then turn the Main Dial until

the desired shutter speed or aperture value is displayed. This only works for one exposure at a time, making it useful for quick-and-easy shooting while retaining some control over camera settings.

If the system determines there is risk of a bad exposure, the shutter speed and aperture values will blink in the viewfinder. When this occurs because there is too much light, decrease the ISO setting. If there is insufficient light, increase the ISO speed.

Tv Shutter-Priority AE Mode: Tv (time value) signifies Shutter-Priority AE, in which you set the shutter speed and the camera sets the aperture. If you want a particular shutter speed for artistic reasons—perhaps a high speed to stop action or a slow speed for blur effect—use this setting. In this mode, even if the light varies, the shutter speed will not. The camera will keep up with changing light by adjusting the aperture automatically.

If the aperture indicated in the viewfinder or the LCD panel is consistently lit (not blinking), you have a good exposure based on what is possible with your lens' f/stops and the shutter speed chosen. If the maximum aperture (lowest number) blinks, it means the photo will be underexposed because there is no aperture appropriate to the chosen shutter speed. You then need to select a slower shutter speed by turning the Main Dial until the aperture indicator stops blinking. You can also fix this by increasing the ISO speed. If the minimum aperture (highest number) is blinking, this indicates overexposure because, again, the camera cannot choose an f/stop that will work with the set shutter speed. In this case, you should set a faster shutter speed until the blinking stops, or choose a slower ISO speed.

Av Aperture-Priority AE Mode: When you select **Av** (aperture value), you set the aperture (the f/stop, or lens opening) and the camera selects the proper shutter speed for a correct exposure. This is probably the most popular Creative setting among professional photographers.

Shutter-priority mode can be a good one to use to maintain a specific shutter speed for a water blur effect. When you're setting slow shutter speeds to achieve this effect, be sure to either use a tripod or make sure you don't set a shutter speed so slow that you cannot hand-hold the camera without causing camera shake.

Controlling depth of field is one of the most common reasons for using **Av** mode. (Depth of field is the distance in front of and behind a specific plane of focus that is acceptably sharp.) While the f/stop, or aperture, affects the amount of light entering the camera, it also has a direct effect on depth of field. A small lens opening (higher f/number) such as f/11 or f/16 will increase the depth of field in the photograph, bringing objects in the distance into sharper focus (when the lens is focused appropriately). High f/numbers such as these are great for landscape photography.

A wide lens opening (low f/numbers), such as f/2.8 or f/4, will decrease the depth of field. These lower f/numbers work well when you want to take a photo of a sharp subject that creates a contrast with a soft, out-of-focus background. If the shutter speed is blinking in the LCD panel, it means good exposure is not possible at that aperture, so you either need to change the aperture or the ISO setting.

You can see the effect of the aperture setting on the image by pushing the Depth-of-Field Preview button on the camera (located on the lower left of the front lens housing, below the Lens Release button). This stops the lens down to the taking aperture and reveals sharpness in the resulting darkened viewfinder (the lens otherwise remains wide open until the next picture is taken). Using Depth-of-Field Preview takes some practice because of the viewfinder darkness. But changes in focus can be seen if you look hard enough. You can also just check focus in the LCD monitor after the shot (magnify it as needed), since digital allows you to both review and/or delete your photos as you go.

A sports or wildlife photographer might choose **Av** mode in order to stop action rather than to control depth of field. To accomplish this, he or she selects a wide lens opening—perhaps f/2.8 or f/4—to let in the maximum amount of light. In **Av** mode, the camera will then automatically select the fastest shutter speed possible for the conditions. With **Tv** mode, while you can set a fast shutter speed, the camera still may not be able to expose correctly if the light

Aperture-priority mode is perfect for when you want to control the amount of sharpness in depth by using a certain f-stop. I.e., setting a larger aperture for this picture would have blurred everything behind the point of focus even more, and of course the opposite effect would have resulted from setting a smaller aperture.

drops and the selected shutter speed requires an opening larger than the particular lens can provide (the aperture value will blink in the viewfinder in such a case). So, typically photographers will select **Tv** only when they have to have a specific shutter speed. Otherwise, they use **Av** for both depth of field and to gain the highest possible shutter speed for the circumstances.

A-DEP Automatic Depth-of-Field AE: This is a unique exposure mode that Canon has used on a number of EOS SLRs (both film and digital) over the years. A-DEP simplifies the selection of an f/stop to ensure maximum depth of field for a subject. The camera actually checks focus, comparing all nine AF points to determine the closest and farthest points in the scene. The camera then picks an aperture to cover that distance and the appropriate shutter speed. You cannot control either yourself. It also sets the focus distance. If the camera cannot get an aperture to match the depth of field needed to cover the near and far points, the aperture will blink. You can check what the depth of field looks like by pushing in the Depth-of-Field Preview button. You have to use AF on the lens; MF will make the camera act as if P were set. A-DEP also does not work with flash, and the camera will act as if **P** were set in that case, too.

Manual Exposure Mode: The Manual Exposure option is important for photographers who are used to working in full manual (although I would suggest that everyone at least try the automatic settings at times to see what they can do; this camera is designed to give exceptional autoexposures), and also for anyone who faces certain tricky situations. In Manual Exposure, you set both the shutter speed (using the Main Dial) and the aperture (point the power switch to the top setting), then select your desired f/stop with the Quick Control Dial). You can use the exposure metering systems of the camera—exposure is visible on the scale at the bottom of the viewfinder's information display. "Correct" exposure is at the mid-point, and you can see how much the exposure settings vary from that point by observing the scale. It displays up to two f/stops over or under the mid-point, which can allow you to quickly compensate for

bright or dark subjects. If part of the scale blinks, the exposure is off the scale, so you must change either the shutter speed or the aperture. Of course, you can also use a hand-held meter.

The following examples of complex metering conditions might require you to use **M** mode: panoramic shots that will later be stitched together in the computer (you need a consistent exposure across the required multiple shots, and the only way to ensure that is with Manual); lighting conditions that change rapidly around a subject with consistent light (a theatrical stage, for example); close-up photography where the subject is in one light but slight movement of the camera dramatically changes the light behind it; and any conditions where you need a consistent exposure through varied lighting conditions.

Insider View: I frequently use Manual Exposure for controlling flash and ambient light. The flash will give you a normal flash exposure based on the aperture chosen. The shutter speed will then control the brightness of the background. You can actually change how bright or dark the background is by adjusting the shutter speed so that the exposure is anything from one-third to several stops underexposed (the background will simply turn black beyond that).

Choosing Shutter Speeds (Tv or M)

The 50D offers a choice of speeds, from 1/8000 second up to 30 seconds in 1/3-stop increments, plus Bulb setting (you can also change the increments to 1/2 stops with C.Fn. I-1). For flash exposures, the camera will sync at 1/250 second or slower (which is important to know since slower shutter speeds can be used to pick up ambient or existing light in a dimly-lit scene). Let's examine these shutter speeds by grouping them as "fast," "moderate," and "slow."

Fast shutter speeds are 1/500–1/8000 second. The obvious reason to choose these speeds is to stop action. The more the action increases in pace, or the closer it crosses directly in front of you, the higher the speed you will need. (Of course, you can check your results immediately on the LCD monitor to see if the shutter speed has in fact frozen the action.)

At these fast speeds, camera movement during exposure is rarely significant unless you try to hand-hold a super telephoto lens of 600mm (not recommended!). This means with proper hand-holding technique, you can shoot using most normal focal lengths (from wide-angle to telephoto up to about 300mm) with few problems from camera movement.

Besides stopping action, high shutter speeds allow you to use lenses at wide openings (such as f/2.8 or f/4) for selective focus effects (shallow depth of field). In bright sun, for example, you might have an exposure of 1/200 second at f/16 with an ISO setting of 200. You can get to f/2.8 by shortening your speed five whole steps of exposure, to approximately 1/4000 second.

Moderate shutter speeds (1/60-1/250 second) work for most subjects and allow a reasonable range of f/stops to be used. They are the real workhorse shutter speeds, as long as there's no fast action.

Insider View: Hand-holding cameras at the lower end of this range, especially with telephoto lenses, may cause blur in your pictures due to movement of the camera during the exposure. I find in tests I have done that most photographers cannot hand-hold a camera with moderate focal lengths (50-150mm) at shutter speeds less than 1/125 second without some degradation of the image due to camera movement. There is an easy way to see how well you can do: Take two photos of a scene, one with the camera hand-held and one with the camera on a tripod. Compare them to see at what shutter speed you can match the tripod.

Slow shutter speeds (1/60 second or slower) allow small apertures and low ISO settings for very high quality images, plus they can be used for low-light conditions and creative blurs. However, they do require something to stabilize the camera. Some photographers may discover they can hand-hold a camera and shoot relatively sharp images at the high end of this range, but most cannot get optimal sharpness from their lenses at these speeds without a tripod or other support.

Blurs can be fun to try with slow shutter speeds and movement in the photo. Use your LCD to help you choose the best shutter speed.

A fun use of very slow shutter speeds (1/8-1/2 second) is to photograph movement, such as a waterfall or people running, or to move the camera during exposure, such as panning it across a scene. The effects are quite unpredictable but can be interesting. Again, reviewing the photo on the LCD monitor helps you determine whether your technique worked or not. You can try different shutter speeds and see what they look like. This is helpful when trying to choose a slow speed appropriate for the subject because each speed will blur action differently.

Insider View: I like to experiment with blurs, but I could never figure out what was the best speed when shooting with film. Now I can try a shutter speed, review the picture in the LCD monitor to see how the speed works with the action, then revise my choice accordingly.

You can set slow shutter speeds (up to 30 seconds) for special purposes such as capturing fireworks or moonlit landscapes. Canon has engineered the sensor and its accompanying circuits to minimize noise (a common problem of long exposures with digital cameras) and the 50D offers excellent results with these exposures.

You can take even longer exposures if you are willing to time them yourself with the **BULB** setting. **BULB** allows you to control long exposures (buLb follows 30 seconds when scrolling through shutter speeds). With this option, the shutter stays open as long as you keep the shutter button depressed. Let go and the shutter closes. The Canon RS-80N3 remote switch and the time remote controller TC-80N3 are very helpful for these long exposures, since they allow you to keep the shutter open without touching the camera (which can cause movement)—they attach to the camera with quick-lock plugs to the remote terminal on the left side. You can use the infrared LC-5 wireless remote switch for bulb exposures as well.

The camera will show the elapsed time in seconds for your exposure as long as you keep the remote switch depressed. It is a good idea to use C.Fn II-1—Long exposure noise reduction (see page 109). This will apply added incamera noise reduction.

Flash

Flash photography can be intimidating. I see this in my workshops all the time. Even photographers who own several flash units are often reluctant to use them. flash has a long photographic history of being rather mysterious, partly because in film photography there was no way of seeing what actually happened until the film was processed. Even the pros relied on Polaroid tests because they could not totally predict what the flash would look like in the photo.

Although there still is the psychological intimidation factor of flash, digital photography really has taken some of the mystery out of the process. The LCD monitor on your 50D that will instantly show you the effects of any use of flash. You can then adjust the light level, change the angle, soften the light, color it, and more. You can experiment with the 50D's built-in flash, or you may find you prefer an accessory flash.

With the purchase of your Canon EOS 50D, you gained more than a camera. You also gained access to an outstanding accessory flash system. The Canon EX Speedlite flash system includes a excellent range of flash units, from the basic to the extremely sophisticated.

The Canon flash system can produce excellent results without a great deal of additional gear. This shot was made with one flash bounced from a white card at the right of the subject and a white card reflector on the left.

An off-camera flash, held to the right of the flowers, lights the white blossoms and allows the background to be darker.

Using Flash

Electronic flash is not just a supplement for low light; it can also be a wonderful tool for creative photography. Flash is highly controllable, its color is precise, and the results are repeatable. However, the challenge is getting the right look, and many photographers shy away from using flash because they aren't happy with the results. This is because on-camera

flash can be harsh and unflattering, and taking the flash off the camera used to be a complicated procedure with less than sure results. Combined with immediate image review, the EOS 50D's sophisticated flash system eliminates many of these concerns, alleviating the guesswork.

Here are some possibilities for using flash with your EOS 50D:

- Fill Flash—Fill harsh shadows in all sorts of conditions and use the LCD monitor to see exactly how well the fill flash is working. You can even dial down the built-in or accessory flash to make its output more natural looking.
- Off-Camera Flash—Putting a flash on a dedicated flash off-camera shoe cord will allow you to move the flash to positions away from the camera and still have it work automatically. Again, you can see exactly what the effects are in the LCD monitor, allowing you to move the flash up or down, left or right, to create the best light and shadows on your subject. With Canon's EX Speedlites, you can also trigger certain units wirelessly with full autoexposure capability, so you can have a flash off the camera with no cords attached and proper exposure.
- Close-Up Flash—This used to be a real problem, except for those willing to spend some time experimenting. Now you can see exactly what the flash is doing to the subject. This works fantastically well with off-camera flash, as you can feather the light (aim it so it doesn't hit the subject directly) control its strength and how it lights the area around the subject. Though you can use most Canon EX Speedlites for close-up photography, the system also includes a special twin-flash macro unit.
- Multiple Flash—Modern flash systems have made exposure with multiple flash easier and more accurate. Plus, many manufacturers have created cordless systems. However, since these flash units are not on continuously, it has often been difficult to know where to place them so that they light the subject properly. Not anymore. With

the 50D it is easy to set up the flash and take a test shot. Does it look good or not? Make changes if needed. In addition, this camera lets you use certain EX-series flash units (and independent brands with the same capabilities) that offer wireless exposure control. Digital photography is a great way to learn how to master multiple flash set ups.

• Colored Light—With multiple light sources, you can attach colored filters (also called gels) to the various flashes so that different colors light different parts of the photo (this can be a very trendy look).

Insider View: Many flashes look better with a slight warming filter on them. This doesn't have to be anything fancy. You can simply buy a warming filter used for lighting and cut small pieces to fit over the front of your unit's lens. Just tape them in place. You can also buy small filters made specifically for this purpose.

Balancing Mixed Lighting—Architectural and corporate
photographers have long used added light to fill in dark
areas of a scene so the scene looks less harsh. Now you
can double-check the light balance on your subject
using, yes, the LCD monitor. You can even be sure the
added light is the right color by attaching filters to the
flash to mimic or match lights (such as a green filter to
match fluorescents or an amber filter to blend with
incandescent lights).

Flash Synchronization

The EOS 50D camera is equipped with an electromagnetically timed, vertically traveling focal-plane shutter. This shutter uses two curtains, one opens to expose the sensor to light, the second closes to shut off that light. (The 50D also uses an electronic first curtain with its Live View). For normal flash operation, the flash must go off when the sensor is fully exposed to light from the lens. One characteristic of focal-plane shutters, however, is that the surface of the sensor will not be entirely exposed at one time using

shutter speeds faster than the flash sync speed. What happens is that the second curtain starts closing before the first one has finished going across the sensor. The shutter then forms a slit, which exposes the sensor as the slit moves across the sensor. If you use flash with a shutter speed that is higher than the fastest flash sync speed of 1/250 second, you get only a partially exposed picture. However, at shutter speeds below the maximum, from 1/125 second to 30 seconds, the whole sensor surface will be exposed at some point to accept the flash.

With the 50D, the fastest shutter speed you can use for flash sync is 1/250 second —if you try to set the exposure to a speed faster than that in Tv or M modes when using flash, the camera will automatically reset the speed to 1/250. But the camera does offer a special high-speed sync mode with certain EX-series flash units that allows flash at all shutter speeds (even 1/8000 second where, basically, the flash fires continuously as the slit travels across the sensor). High-speed synchronization must be activated on the flash unit itself and is indicated by an H symbol on the flash unit's LCD panel—see the flash manual for specific information on using high-speed flash sync. It does have some limitations, including how much power you get.

Insider View: High-speed sync is pretty limited in its uses. Many photographers never find a use for it.

Guide Numbers

When shopping for a flash unit, compare guide numbers. A guide number (GN) is a simple way to state the power of the flash unit (it's computed as the product of aperture value and subject distance) and is usually included in the manufacturer's specifications for the unit. High numbers indicate more power, however, it is important to understand that these numbers do not represent a linear relationship. Guide numbers act a little like f/stops (because they are directly related to f/stops!)—e.g., 56 is half the power of 80, while 110 is twice the power of 80. Since guide numbers are expressed in feet or meters, and ISO is part of the formula,

check the ISO and distance references to make sure they are similar when comparing flash units. If the units you are comparing have zoom-head controls, make sure you compare the guide numbers for similar zoom-head settings.

Built-In Flash

The flash built into the 50D's pentaprism housing at the top of the camera is really quite convenient. It gives you access to flash at all times, although the power is limited. This flash pops up higher than many older camera's built-in flash, thereby reducing the chance of getting red-eye and minimizing problems with large lenses blocking the flash. The flash also supports Canon's sophisticated E-TTL II metering system for flash, covers a field of view up to a 17mm focal length and has a guide number of 43/13 (feet/meters) at ISO 100.

Insider View: A higher built-in flash definitely helps, but does not eliminate red-eye or problems with large lenses. You will find that big zoom lenses with large front ends will consistently create a dark shadow over your subject when using the built-in flash (especially when you use the lens shade for that lens).

The 50D's built-in flash is, like most built-in flash units, not particularly powerful, but it is always available and can often be used as fill flash to modify ambient light. The flash pops up automatically in low light or in backlit situations in the following Basic Zone shooting modes: Full Auto, Portrait, Close-Up, and Night Portrait. It will not activate in Landscape, Sports, or Flash Off modes. In the Creative Zone, you can choose to use the flash or not at any time. Just press the flash button \$\frac{1}{2}\$ located on front of the camera on upper left of the lens mount housing, and the flash will pop up. To turn it off, simply push the flash down.

The built-in flash of the 50D is convenient because it is always available.

There are some variations in how the Creative Zone shooting modes work with the built-in flash. Program is fully automatic and will choose a sync speed and aperture. To can be used when you need a specific shutter speed (as long as it is 1/250 second or slower). Av is very useful because it lets you easily balance the light from the flash with the existing or ambient light of your scene—you set an aperture that the flash uses for its exposure and then the shutter speed influences how much of the ambient light (or natural light) will appear in the image. For Manual Exposure mode, you set the aperture for the flash then choose a shutter speed that is appropriate for your subject and its surroundings (1/250 second and slower).

Flash Metering

The 50D uses an evaluative auto exposure system, called E-TTL II. To understand the 50D's flash metering, you need to understand how a flash works with a digital camera on automatic. The camera will fire the flash twice for the exposure.

First, a preflash is fired before the shutter opens to allow the camera to analyze exposure, and then the flash fires during the actual exposure when the shutter is open, creating the image. During the preflash, the camera's evaluative metering system measures the light reflected back from the subject. Once it senses that the light is sufficient, it cuts off the flash and takes the actual exposure with the same flash duration. The amount of flash hitting the subject is based on how long the flash is on, so close subjects will receive shorter flash bursts than more distant subjects.

Insider View: This double flash system works quite well, except for people really sensitive to flash. I cannot use it with my wife. She reacts to the first flash burst so that her eyes are closed during the real exposure (or at least partially closed). While not common, this does happen with certain people. Check your LCD to be sure you are getting people's eyes open. This can be a hard thing to beat with some subjects. You can try varying when you take your picture; you can also try Manual exposure on both flash and camera so that there is no preflash.

You can lock the flash exposure when using either the pop-up flash or an attached flash by pressing the Flash Exposure lock (FE lock) \bigstar button when the flash is on (this is the same as the AE lock button located on the back of the camera in the upper right shoulder). This causes the camera to emit a non-exposing flash so that it can calculate the exposure before taking the shot. This also cancels the preflash described above that normally occurs immediately before the actual photograph (reducing the problem with people reacting to that preflash a split-second before the photo).

To use FE lock, turn the flash on, then lock focus on your subject by pressing the shutter button halfway (this is important because the camera will use distance information to help calculate the proper exposure). Next, aim the center of the viewfinder at the important part of the subject and press to fire the "calculating" flash (icons of a lightning bolt

and asterisk will appear in the viewfinder). Now, reframe your composition and finish pressing the shutter button all the way to fire the flash and take the picture. FE lock produces quite accurate flash exposures.

Insider View: You can use this same feature to make the flash weaker or stronger. Instead of pointing the viewfinder at the subject to set flash exposure, point it at something light in tone or a subject closer to the camera. That will cause the flash to give less exposure. For more light, aim the camera at something black or far away. With a little experimenting, and by reviewing the LCD monitor, you can very quickly establish appropriate flash control for particular situations.

For the most control over flash, use the 50D's Manual exposure setting. Set an exposure that is correct overall for the scene then turn on the flash (flash exposure will still be E-TTL automatic.) The shutter speed (as long as it is 1/250 second or slower) controls the overall light from the scene (and the total exposure). The f/stop controls the exposure of the flash. So to a degree, you can make the overall scene lighter or darker by changing shutter speed, with no direct effect on the flash exposure (this does not work with highspeed flash or if the flash is set to manual).

Flash with Camera Exposure Modes

In the Basic Zones, you have no control over the flash. This means you have no say in when flash will be used for an exposure or how the exposure is controlled. The camera determines it all depending on how it senses the scene's light values. It will automatically be used when either the light is dim or there is a strong backlight.

In the Creative Zones, you either pop up the built-in flash by pushing the \$\forall button, or attach an EX Speedlite accessory flash unit and simply switch it on. The flash will then operate in the various Creative Zone modes as follows:

Program AE (P)

Flash photography can be used for any photo where supplementary light is needed. All you have to do is turn on the flash unit—the camera does the rest automatically. Speedlite EX flash units should be switched to E-TTL and the ready light should be on, indicating that the flash is ready to fire. While shooting, you must pay attention to the flash symbol in the viewfinder to be sure that the flash is charged when you are ready to take your picture. The 50D automatically sets flash synchronization shutter speeds of 1/60–/250 second in P mode, and also selects the correct aperture. When the flash is turned on, any Program shift that has been set will be canceled.

Shutter-Priority AE (Tv)

This mode is a good choice in situations where you want to control the shutter speed when you are also using flash. In Tv mode, you set the shutter speed before or after a dedicated accessory flash is turned on. All shutter speeds between 1/250 second and 30 seconds will synchronize with the flash. With E-TTL Flash in Tv mode, synchronization with long shutter speeds is a creative choice that allows you to control the ambient-light background exposure. A portrait of a person at dusk in front of a building with its lights on shot with conventional TTL flash would illuminate the person correctly but would cause the background to go dark. However, using Tv mode, you can control the exposure of the background by changing the shutter speed. (A tripod is recommended to keep the camera stable during long exposures).

Aperture-Priority AE (Av)

Using this mode lets you balance the flash with existing light, and it allows you to control depth of field in the composition. By selecting the aperture, you are also able to influence the range of the flash (large apertures such as f/4 give a longer range, while small apertures such as f/16 give a smaller, closer range). The aperture can be selected by turning the and watching the accessory flash's LCD panel until the desired range appears. Then the camera calculates

Manual flash gives the best ability to control both the flash exposure on the subject and the ambient light in the scene.

the lighting conditions and automatically sets the correct shutter speed for the ambient light (but no faster than the sync speed of 1/250 second).

Manual Exposure (M)

Manual gives you the most choices in modifying exposure. This is fairly easy to do with the 50D because you can see the results instantly in the LCD. The photographer who adjusts everything manually can determine the relationship of ambient light and electronic flash by setting both the aperture and shutter speed. Any aperture on the lens and all shutter speeds between 1/250 second and 30 seconds can be used. If a shutter speed above the normal flash sync speed is set, the 50D switches automatically to 1/250 second to prevent partial exposure of the sensor.

Manual exposure mode also offers a number of creative possibilities for using flash in connection with long shutter speeds. The neat thing is that you don't have to calculate flash exposure manually because the flash sets exposure based on the f/stop you choose, plus you can check exposure in the LCD. For example, you could choose a very slow shutter speed and then zoom during the exposure. You will get a zooming effect with a smeared background yet you will also have a sharply rendered main subject from the flash. You can also take photographs of objects in motion with a sharp "flash core" and indistinct outlines.

Flash Exposure Compensation

There will be times that flash will give to much or too little exposure on your subject. The easiest way to deal with this is to use flash exposure compensation. Press the ISO-122 button at the top right shoulder of your camera. A scale appears at the bottom left of the LCD panel on top of your camera. This looks very similar to the scale that appears normally in that position for overall exposure compensation.

Simply use to change the amount of flash exposure compensation on that dial. Moving the pointer on the dial to the left reduces flash exposure while moving it to the right increases flash exposure up to +/- 2 f/stops. It is important to keep in mind that this is only affecting the flash exposure. A background that is unaffected by the flash, for example, will not be changed in brightness by changing the flash exposure compensation.

First and Second Curtain Flash

The EOS 50D offers two ways that it syncs the flash with the shutter speed first curtain sync and second curtain sync. In order to choose between these options, it helps to review the way in which flash works with the shutter speed. When the shutter first goes off, there is a shutter curtain that drops down to expose the sensor. When the shutter speed is reached, a second curtain drops down to block light from the sensor. With first curtain sync, the

flash goes off as soon as the first curtain is open. With second curtain sync, the flash does not go off right away, and "waits" until the exposure is about to end, just before the second curtain closes.

First curtain sync is the default that comes preset by the camera. You can choose second curtain sync in view of the item for Flash control. Flash control offers several options for the camera to deal with both the built-in and accessory flashes. Scroll to Built-in flash func. setting and press scroll to Shutter sync and press again. Select either 1st curtain and 2nd curtain.

There is little difference between these two choices at faster shutter speeds. As your shutter speed lengthens, however, there can be a significant difference if you have a subject that is moving through your picture area. With first curtain sync, the flash goes off right away and creates a sharp image of the subject at the beginning of the shutter speed. Then the subject moves during the rest of the exposure, hopefully creating an interesting blur. The result is that the movement blur appears in front of a sharp subject.

With second curtain sync, the subject moves during the exposure first, creating some sort of blur. Then the flash goes off just before the exposure ends, creating a sharp image of the subject after the blur. The result is that the movement blur appears behind the sharp subject.

Red-Eye Reduction

The 50D does offer a red-eye reduction feature for flash exposures. In low-light conditions when the flash is close to the axis of the lens (which it is with built-in flash), the flash will reflect back from the retina of peoples' eyes (because their pupils are wide). This appears as red eyes in the photo. You can reduce the chances of red-eye appearing by using an off-camera flash or by having the person look at a bright light before shooting.

The red-eye reduction feature of a camera is designed to cause the pupils of your subject to contract. On many cameras this is of questionable value because the flash fires a burst of light before the actual exposure. This often causes less than flattering expressions from your subject. The 50D, on the other hand, uses a continuous light from a bulb next to the handgrip, just below the shutter button (you do have to be careful not to block it with your fingers), which helps the subject pose with better expressions. Red-eye reduction is set in

Insider View: Red-eye reduction doesn't always work. Some people just create more of a red-eye effect than others. Also, the light on the camera doesn't work all that well if you are far away from your subject. Red-eye reduction also creates another challenge because it takes you longer to actually get the photo.

Canon Speedlite EX Flash Units

Canon offers a range of accessory flash units in the EOS system, called Speedlites. While Canon Speedlites don't replace studio strobes, they are remarkably versatile. These highly portable flash units can be mounted in the camera's hot shoe or used off-camera with a dedicated cord. The 50D is compatible with the EX-series of Speedlites. The EX-series flash units range in power from the Speedlite 580EX II, which has a maximum GN of 190/58 (feet/meters) at ISO 100, to the small and compact Speedlite 220EX, which has a GN of 72/22 (feet/meters) at ISO 100. Speedlite EX-series flash units offer a wide range of features to expand your creativity. These are designed to work with the camera's microprocessor to take advantage of E-TTL exposure control, which extends the abilities of the 50D considerably.

Both built-in flash and external Speedlite settings can be set from the camera with **\Pi**: under the item for *Flash control*. With the external EX-series Speedlites, this includes options for *Flash mode, Shutter sync., FEB* (Flash Exposure

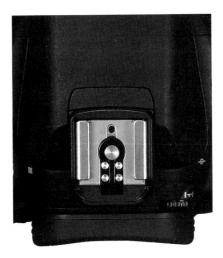

The multiple contact points of the flash shoe allow sophisticated communication between camera and flash.

Bracketing), Flash exp. comp, E-TTL II, Zoom, Wireless flash, and Clear Speedlite settings.

Insider View: I strongly recommend getting Canon's Off-Camera Shoe Cord OC-E3, an extension cord for your accessory flash. With this cord, the flash can be moved away from the camera for more interesting light and shadow. You can aim light from the side or top of a close-up subject for variations in contrast and color. If you find that you get an overexposed subject, rather than dialing down the flash (which can be done on certain flash units), just aim the flash a little away from the subject so it doesn't get hit so directly by the light. That is often a quick fix for overexposure of close-ups. While it is true that you can use an off-camera flash with wireless flash, this does not work 100 percent of the time for a single off-camera flash, especially when you are outdoors.

Canon Speedlite 580EX II

This top-of-the-line flash unit offers outstanding range and features adapted to digital cameras. It is a powerful and fast unit with moisture and dust sealing. The tilt/swivel zoom head on the 580EX II covers focal lengths from 14mm to 105mm, and it swivels a full 180° in either direction. The

An accessory flash such as this Speedlite 580EX II offers much more power and flexibility than the built-in flash.

zoom positions (which correspond to the focal lengths 24, 28, 35, 50, 70, 80, and 105mm) can be set manually or automatically (the flash reflector zooms with the lens). In addition, this flash determines what size sensor is used with a D-SLR and will vary its zoom accordingly. With the built-in retractable diffuser in place, the flash coverage is wide enough for a 14mm lens. It provides a high flash output with a GN of 190/58 (feet/meters) at ISO 100 when the zoom head is positioned at 105mm. The guide number decreases as the angular coverage increases for shorter focal lengths, but is still quite high with a GN of 145/44 (feet/meters) at ISO 100 using a focal length of 50mm, or GN 103/31 (feet/meters ISO 100) at 28mm.

Direct flash can often be harsh and unflattering, causing heavy shadows behind the subject or underneath features such as eyebrows and bangs. Bouncing the flash softens the light and creates a more natural-looking light effect. The Canon Speedlite 580EX II (as well as the 430EX accessory

flash described next) features a head that tilts so when shoe-mounted can be aimed at the ceiling to produce soft, even lighting. The 580EX II also swivels (180° in both directions) so the light can be bounced off something to the side of the camera (a wall or reflector). However, the ceiling or wall must be white or neutral gray, or it may cause an undesirable color cast in the finished photo.

The large, illuminated LCD panel on the 580EX II provides clear information on all settings: flash function, reflector position, working aperture, and flash range in feet or meters. The flash also includes a Select Dial for easier selection of these settings. When you press the 50D's Depth-of-Field Preview button (on lower left of the lens mount housing), a one-second burst of light is emitted. This modeling flash allows you to judge the effect of the flash. The 580EX II also has 13 user-defined custom settings that are totally independent of the camera's custom functions; for more information, see the flash manual. When using multiple flashes, the unit can be used wirelessly either as a master flash or a slave unit.

Canon Speedlite 430EX

The 430EX is less complicated, more compact, and less expensive than the top models. It has a 40% faster recycling time than the old 420EX. It offers E-TTL flash control, wireless E-TTL operation, and high-speed synchronization. The 430EX flash unit provides high performance with a GN of 141/43 (feet/meters) at ISO 100 with the zoom reflector set for 105mm (about a stop less than the 580EX II, but still quite powerful). The tilt/swivel zoom reflector covers focal lengths from 24mm to 105mm. The zoom head operates automatically for focal lengths of 24, 28, 35, 50, 70, and 105mm. The setting for wireless E-TTL is made on the flash foot. It includes six flash custom functions. When using multiple flashes, the 430EX can be used as a slave unit, but not as a master flash.

Canon Speedlite 430EX II

The 430EX is an advanced version of the 430EX. It is quieter and has a 20% faster recycling time than the 430EX. Otherwise it is pretty much the same, although it does include a metal foot for added strength and stability in the flash shoe mount, which can be very important if you are using flash a lot.

Canon Speedlite 220EX

This little flash is the smallest and lightest of the group, yet still offers full E-TTL exposure control. It has a fixed angle of light that will cover up to a 17mm lens on the 50D.

Other Speedlites

The Canon system also includes two specialized flash units for close-up photography that work well with the EOS 50D: the Macro Twin Lite MT-24EX and the Macro Ring Lite MR-14EX. They provide direct light on the subject.

Macro Twin Lite MT-24EX

The MT-24EX uses two small flashes affixed to a ring that attaches to the lens. These can be adjusted to different positions to alter the light and can be used at different strengths so one can be used as a main light and the other as a fill light. If both flash tubes are switched on, they produce a GN of 72/22 (feet/meters) at ISO 100, and when used individually the guide number is 36/11 (feet/meters). It does an exceptional job with directional lighting in macro shooting.

Macro Ring Lite MR-14EX

The MR-14EX has a GN of 46/14 (feet/meters) at ISO 100, and both flash tubes can be independently adjusted in 13 steps from 1:8 to 8:1. It is a flash that encircles the lens and provides illumination on axis with it. This results in nearly shadowless photos (the shadow falls behind the subject compared to the lens position, though there will be shadow effects along curved edges). This flash is often used by photographers who want to show all the fine detail and

color in a subject. It cannot be used for varied light and shadow effects. This flash is commonly used in medical and dental photography so that important details are not obscured by shadows.

Insider View: It is true that the Ring Lite makes close-up work easy with flash, but it gives a consistently flat light, which I find boring for creative nature macro photography. The Twin Lite is much more versatile for creative and controlled close-up lighting.

The power pack of both of these specialized flash units fits into the flash shoe of the camera. In addition, both macro flash units offer E-TTL operation, wireless E-TTL flash, and high-speed synchronization.

Wireless E-TTL Flash

To operate wireless E-TTL, a Speedlite 580EX II, 580EX, or 550EX is mounted in the flash shoe on the camera (the last two speedlites have been discontinued by Canon, but of course are still in use by many photographers). The switch on the unit's foot should be set so that it functions as a master unit; and slave units are set up in the surrounding area. You can use up to three groups of Speedlites (580EX II, 580EX, 550EX, 430EX, or 420EX) for more natural lighting or emphasis—the number of flash units is unlimited even though three is the maximum number of groups. The master unit and the camera control the exposure. The 430EX and 430EX II can only be used as slave units, and the light ratio of slave units can be varied manually or automatically. Other wireless flash options include the Speedlite infrared transmitter (ST-E2) or the Macro Twin Lite MT-24EX.

Lenses and Accessories

One of the great advantages to using Canon equipment is your access to a huge range of accessories, not just flash, but also over 90 different lenses from ultra wide to super telephoto, single focal length, and zooms. In addition, Canon has a well-deserved reputation for innovation and quality in their lenses. With this wide range of available options, you could expand the capabilities of your 50D quite easily should you want to. Several independent manufacturers offer quality Canon compatible lenses as well.

The 50D can use both Canon EF and EF-S lenses, ranging from wide-angle to tele-zoom, as well as single focal length lenses, from very wide to extreme telephoto. Keep in mind that magnification of both the widest angle and the farthest zoom are multiplied by the 50D's 1.6x magnification factor when compared to how such lenses act with 35mm cameras. This is because the dimensions of an APS-C sensor, the format used in the 50D (22.3 x 14.9 mm), are smaller than those found in traditional 35mm film or the full frame 35mm format sensor (36 x 24 mm). Consequently the same lens covers the scene differently.

The EF 14mm f/2.8L lens, for example, is a super-wide lens with a 35mm camera, but offers the 35mm-format equivalent of a 22mm lens when attached to the EOS 50D—wide, but not super-wide. On the other hand, put a 400mm lens on the camera and you get the equivalent of a 640mm telephoto—a big boost with no change in aperture (be sure to use a tripod for these focal lengths)! You get an effectively long focal length in a smaller lens, often with a wider maximum f/stop, and with a much lower price.

A macro lens on your Canon EOS 50D is an excellent way to explore details of nature that are not often noticed by most people. Insider View: You may hear a bit of pontification about this multiplication factor from would-be experts who are more interested in denigrating the smaller format than in being useful. The "multiplication factor" is nothing new with digital. It is exactly the same thing that happens when one focal length is used with different sized film formats. For example, a 50mm lens is considered a mid-range focal length for 35mm, but it would be a wide-angle for medium format cameras. So, in essence, 35mm "crops" the image seen by a focal length when compared to medium format. But the bottom line is what you get in your photographs. You get more magnification in your image area whenever a smaller format is used compared to a larger format with the same focal length.

Choosing Lenses

The focal length and design of a lens will have a huge affect on how you photograph. The correct lens will make photography a joy; the wrong one will make you leave the camera at home. Certain subjects lend themselves to specific focal lengths. On D-SLRs using the APS-C format, like the 50D, wildlife and sports action are best photographed using focal lengths of 200mm or more. Portraits look great when shot with focal lengths between 50 and 80mm. Interiors often demand wide-angle lenses such as 10 or 16mm. Many people also like wide angles for landscapes, but telephotos can come in handy for distant scenes. Close-ups can be shot with nearly any focal length, though skittish subjects such as butterflies might need a rather long lens (meaning strong telephoto).

Insider View: One approach for choosing a lens that I find useful for most photographers is to think about how you are frustrated with your current lenses. Do you constantly want to see more of the scene than the lens will allow? Then consider a wider-angle lens. Or maybe the subject is too small in your photos. Then look into acquiring a telephoto zoom or single-focal length telephoto lens.

There are added burdens to changing a lens on your D-SLR in snowy weather (gloves, cold and wet conditions, etc.) So a zoom lens is advantageous in winter because allows you to change focal lengths without removing the lens.

Zoom vs. Prime Lenses

When zoom lenses first came on the market, they were not even close to prime (single focal length) lenses in sharpness, color rendition, or contrast. Today, you can get superb image quality from either type. There are some important differences, though. The biggest is maximum f/stop.

Zoom lenses are rarely as fast (i.e. rarely have as big a maximum aperture) as prime lenses. Canon's EF 70–300mm DO IS USM zoom, for example, has a maximum aperture of f/5.6 at 300mm, yet Canon also produces a super telephoto EF 300mm prime lens that is f/2.8. When zoom lenses come close to a single focal length lens in f/stops, they are usually

Prime lenses, like this Canon EF 85mm f/1.2, are often faster than zooms and allow better photography in low light.

considerably bigger and more expensive than the single focal length lens. Of course, zooms also offer a whole range of focal lengths, which a prime lens cannot do. There is no question that zoom lenses are versatile.

EF-Series Lenses

Canon EF lenses include some unique technologies. Canon pioneered the use of tiny autofocus motors in its lenses. In order to focus swiftly, the focusing elements within the lens need to move with quick precision. Canon developed the lens-based ultrasonic motor (USM) for this purpose. This technology makes the lens motor spin with ultrasonic oscillation energy instead of the conventional drive-train system (which tends to be noisy). This allows lenses to autofocus nearly instantly and with no noise (plus it uses less battery power than traditional systems). Canon lenses that utilize this motor are labeled USM (lower-priced Canon lenses have small motors in the lenses too, but they don't use USM technology, and can be slower and noisier).

EF-S Lenses

While EF lenses are the standard lenses for all Canon EOS cameras, the EF-S series offers lenses that are small and compact, designed to only cover the sensor size of an APS-C size sensor. They cannot be used with EOS film cameras, the EOS-1D or 1-Ds series of D-SLRs, or the EOS 5D, because the image area for each of those cameras is larger than that of the 50D's sensor.

EFS lenses are smaller and more compact than similar EF lenses, but they only fit APS-C format cameras like the 50D.

With the launch of the 50D, Canon also introduced a new EF-S lens, the Canon EF-S 18–200mm f/3.5–5.6 IS zoom. This offers quite a remarkable equivalent focal length range (compared to 35mm) of 29-320mm. It focuses to 1.5 feet (.46 meters), which is very close for this type of lens. The lens automatically distinguishes between normal shooting and panning shots and selects the optimum Image Stabilizer

mode. It includes a vibration gyro to detect the difference between normal camera shake and panning movement. The settings for MODE 1/Normal and MODE 2/panning found on other IS lenses are eliminated.

L-Series Lenses

Canon's L-series lenses use special optical technologies for high-quality lens correction. These include low-dispersion glass, fluorite elements, and aspherical designs. Ultra-low dispersion (UD) glass is used in L-series telephoto lenses to minimize chromatic aberration, a common problem for telephoto lens designers. Chromatic aberration occurs when the lens can't focus all colors equally at the same point on the sensor (as well as on the film in a traditional camera). This results in less sharpness and a lot less contrast. Low-dispersion glass focuses colors more equally for sharper, crisper images.

Fluorite elements are even more effective (though more expensive) and have the corrective power of two UD lens elements. Aspherical designs are used with wide-angle and mid focal length lenses to correct the challenges of spherical aberration in such focal lengths. Spherical aberration is a problem caused by lens elements with extreme curvature (usually found in wide-angle and wide-angle zoom lenses). Glass tends to focus light differently through different parts of such a lens, causing a slight, overall softening of the image even though the lens is focused sharply. Aspherical lenses use a special design that compensates for this optical defect.

Insider View: People sometimes wonder if L-series lenses really give that much better image quality to justify the price. The answer is, "It depends." You will find that less expensive lenses will often rival an L-series lens in sharpness when compared using middle range f/stops (such as f/8), and will be very close over most of the rest of the range, close enough to make little difference in smaller prints. L-series lenses, however, do have an edge in what is called image brilliance, or the crispness of fine highlights. This can make

certain images look better. Also, L-series lenses are built to higher standards of durability and sealing, which means that under tough, challenging conditions, they will last longer (but that also means under average conditions, you might not find much difference).

DO-Series Lenses

A relatively recent Canon optical design is the DO, which stands for diffractive optic. This is a very promising technology that significantly reduces the size and weight of a lens, and therefore is especially useful for big telephotos and zooms. Yet, the lens quality is unchanged. The first two lenses produced by Canon in this series are a 400mm pro lens that is only two-thirds the size and weight of the equivalent standard lens, and a 70–300mm IS lens that offers a great focal length range while including image stabilization.

Image Stabilizer Lenses

Canon was a pioneer in the use of image-stabilizing technologies. IS (Image Stabilizer) lenses use sophisticated motors and sensors to adapt to slight movement during exposure. It's pretty amazing—the lens actually has vibration-detecting gyro stabilizers that move a special image-stabilizing lens group in response to movement of the lens. This dampens movement that occurs from hand-holding a camera and allows much slower shutter speeds to be used. IS also allows big telephoto lenses (such as the EF 500mm IS lens) to be used on tripods that are lighter than would normally be used with non IS telephoto lenses.

The IS technology is part of many zoom lenses, and does a great job overall. You will find that you can hand-hold anywhere from 2–4 stops of shutter speed slower with an IS lens compared to a standard lens. More recent lenses tend to give the bigger benefit.

Canon Image Stabilizer lenses include special moving elements in the lens that compensate for camera movement during exposure to give you sharper photos.

However, IS lenses in the mid focal length ranges tend to be slower zooms when matched against single focal length lenses. For example, compare the EF-S 17–85mm f/4–5.6 IS USM lens to the EF 50mm f/1.8. The former has a great zoom range, but allows considerably less light at maximum aperture. At 50mm (a good focal length for taking pictures of people when using the 50D), the EF 17–85mm is an f/4 lens, more than two stops slower than the f/1.8 single focal length lens when both are shot "wide-open" (typical of low-light situations). While you could make up that two stops in "hand-holdability" due to the IS technology, that also means you must use two full shutter speeds slower, which can be a real problem in stopping subject movement.

Macro and Tilt-Shift Lenses

Canon also makes some specialized lenses. Macro lenses are single focal length lenses optimized for high sharpness throughout their focus range, from very close (1:1 or 1:2) magnifications to infinity. These lenses range from 50mm to 180mm. The Canon EF-S 60mm f/2.8 Macro USM lens is designed specifically for the small-format Canon EOS cameras.

Tilt-shift lenses are unique lenses that shift up and down or tilt toward or away from the subject. They mimic the controls of a view camera. Shift lets the photographer keep the back of the camera parallel to the scene and move the lens to get a tall subject into the composition—this keeps vertical lines vertical and is extremely valuable for architectural photographers. Tilt changes the plane of focus so that sharpness can be changed without changing the f/stop. Focus can be extended from near to far by tilting the lens toward the subject, or sharpness can be limited by tilting the lens away from the subject (which has lately been a trendy advertising photography technique).

Independent Lens Brands

Independent lens manufacturers also make some excellent lenses that fit the 50D. I've seen quite a range in capabilities from these lenses. Some include low-dispersion glass and are stunningly sharp. Others may not match the best Canon lenses, but offer features (such as focal length range or a great price) that make them worth considering. To a degree, you do get what you pay for. A low-priced Canon lens compared to a low-priced independent lens probably won't be much different. On the other hand, the high level of engineering and construction found on a Canon L-series lens can be difficult to match.

Filters and Close-Up Lenses

Certain filters can be of great benefit to working with the EOS 50D, especially the polarizing, neutral density, and graduated neutral density filters. Using filters can actually save a substantial amount of work in the digital darkroom by allowing you to capture the desired color and tonalities for your image right from the start.

Insider View: One myth that I often hear is that filters aren't needed for digital photography because adjustments for color and light can be made in the computer. That is absolutely wrong, and such an attitude can limit a photographer's capabilities and the quality of his or her work. Even if you can do certain things in the computer, why take the time if you can do it more efficiently while shooting?

Attaching filters to the camera depends entirely on your lenses—each lens will have a specific filter size. Canon lenses are typically 58mm, 67mm, 72mm, and 77mm. Usually, a properly sized filter can either be screwed directly onto a lens or fit into a holder that screws onto the front of the lens. There are adapters to make a given size filter fit several lenses, but the filter must cover the lens from edge to edge or it will cause dark corners in the photo (vignetting). A photographer may even hold a filter over the lens with his or her hand.

There are a number of different types of very useful filters that perform different tasks for the digital photographer. Among these various filters, some of the most commonly used are described as follows:

Polarizers

This important filter should be in every camera bag. A polarizer darkens skies when the camera is pointed at 90° to the sun, reduces glare, removes reflections, and increases saturation. While you can darken skies in the computer, the polarizer reduces the amount of work you have to perform in the digital darkroom. This filter will rotate in its mount, and as it rotates, the strength of the effect changes. While

linear polarizers often have the strongest effect, they can cause problems with exposure, and often prevent the camera from autofocusing. Consequently, you are safer using a circular polarizer.

Neutral Density Gray Filters

Neutral Density (ND) filters simply reduce the light coming through the lens. They come in different strengths, each reducing different quantities of light. Such filters give additional exposure options under bright conditions, such as a beach or snow (where a filter with a strength of 4x is often appropriate). If you like the effects when slow shutter speeds are used with moving subjects, a strong neutral density filter (such as 8x) usually works well. Of course you can see the effects of slow shutter speeds immediately on the LCD monitor so you can modify your exposure for the best possible effect.

Graduated Neutral Density Filters

Many outdoor photographers consider this filter an essential tool. It is half clear and half dark (gray) with a graduated blending through the middle. It is used to reduce bright areas (such as sky) in tone, while not affecting darker areas (such as the ground). The computer can mimic its effects, but you may not be able to recreate the scene you wanted. A digital camera's sensor can only respond to a certain range of brightness at any given exposure, and if a part of the scene is too bright compared to the overall exposure, detail will be washed out and no amount of work in the computer will bring it back. The graduated ND filter will allow you to bring that bright area down in tone so it is recorded with the proper density in the image.

Insider View: I would not be without a "grad" filter, as it is often called. This filter lets me control the light on a scene so that I can get a better quality exposure, which results in less work in the computer later.

UV and Skylight Filters

The idea behind these types of filters is to protect the front of the lens, but they do very little visually. Still, they can be

You have multiple options for close-up work with your 50D, including close-focusing zooms, the type that was used in this photo.

useful when photographing under such conditions as strong wind, rain, blowing sand, or going through brush. If you do use a filter for lens protection, a high-quality filter is absolutely necessary. A cheap filter can degrade the image quality of the lens. Remember that the manufacturer made the lens/sensor combination with very strict tolerances. A protective filter needs to be literally invisible, and only high-quality filters can guarantee that.

Close-up Accessories

Close-up photography is a striking and unique way to capture a scene. Most of the photographs we see on a day-to-day basis are not close-ups, making those that are all the more noticeable. And a macro lens is not the only way to get close ups. The following are four of the most common close-up options:

Close-focusing zoom lenses with a macro or close-focus feature: Most zoom lenses allow you to focus up-close without accessories, although focal length choices may become limited when using the close-focus feature. These lenses are an easy and effective way to start shooting close-ups. Keep in mind, however, that even though these may say they have a macro setting, it is really just a close-focus setting and not a true macro as described below in macro lenses option.

Close-up accessory lenses: You can buy lenses that screw onto the front of your lens to allow it to focus even closer. The advantage is that you now have the whole range of zoom focal lengths available (if you are using a zoom) and there are no exposure corrections. Close-up filters can do this, but the image quality is not great. More expensive achromatic accessory lenses (highly-corrected, multi-element lenses) do a superb job with close-up work, though their quality is limited by the original lens. Canon makes a couple of achromatic close-up lenses, the 250D and the 500D.

Extension tubes: Extension tubes fit in between the lens and the camera body of an SLR. This allows the lens to focus much closer than it could normally. They offer very high quality, though this depends on the original lens. Extension tubes are designed to work with all lenses for your camera, however, older extension tubes won't work with your 50D. You must get the special EF-S extension tubes made specifically for Canon's EF-S lenses. Be aware that extension tubes do cause a loss of light.

Macro lenses: Though relatively expensive, macro lenses are designed for superb sharpness at all distances and will focus from mere inches to infinity. In addition, they are typically very sharp at all f/stops.

Sharpness is a big issue with close-ups, and this is not simply a matter of buying a well-designed macro lens. Sharpness problems usually result from three factors: limited depth of field, incorrect focus placement, and camera movement.

The closer you get to a subject, the shallower depth of field becomes. You can stop your lens down as far as it will go for more depth of field, or use a lens with a wider angle, but depth of field will still be limited. Because of this, it is critical to be sure focus is placed correctly on the subject. If the back of an insect is sharp but its eyes aren't, the photo will appear to have a focus problem. At these close distances, every detail counts. If only half of the flower petals are in focus, the overall photo will not look sharp.

Insider View: Because of the challenges of close-up focus, autofocus can be a real problem with critical focus placement because the camera will often focus on the wrong part of the photo. This can get very frustrating. It is often better to set the camera to Manual focus. Of course, you can always review your photo on the LCD monitor to be sure the focus is correct before leaving your subject.

A couple of techniques can help with close-up focusing:

- Use Manual focus, and focus the lens at a reasonable distance, then move the camera toward and away from the subject as you watch it go in and out of focus. This can really help, but still, you may find that taking multiple photos is the best way to guarantee proper focus at these close distances.
- Another good technique is to shoot on the continuous drive mode and fire multiple shots. You will often find at least one image with the critical part of your subject in focus. This is a great technique when you are handholding and when you want to capture moving subjects.

When you are focusing close, even slight movement can shift the camera dramatically in relation to the subject. The way to help correct this is to use a high shutter speed or put the camera on a tripod. Two advantages to using a digital camera during close-up work are the ability to check the image to see if you are having camera movement problems, as well as the ability to change ISO settings from picture to picture to enable a faster shutter speed when necessary.

Look for tonal contrasts between your subject and background to bring emphasis to your close ups. And don't forget that Manual focus can help you capture critical points as sharply as possible.

The best looking close-up images will often be ones that allow the subject to contrast with its background, making it stand out and adding some drama to the photo. There are three important contrast options to keep in mind. They apply to any photograph where you want the subject to stand out, but they can be easily applied to close-up subjects where a slight movement of the camera can totally change the background.

• Tonal or brightness contrasts: Look for a background that is darker or lighter than your close-up subject. This may mean a small adjustment in camera position. Backlight is excellent for this since it offers bright edges on your subject with lots of dark shadows behind it.

- Color contrasts: Color contrast is a great way to make your subject stand out from the background. Flowers are popular close-up subjects and, with their bright colors, they are perfect candidates for this type of contrast. Just look for a background that is either a completely different color (such as green grass behind red flowers) or a different saturation of color (such as a bright green bug against dark green grass).
- Sharpness contrast: One of the best close-up techniques is to work with the inherent limit in depth of field and deliberately set a sharp subject against an out-of-focus background or foreground. Look at the distance between your subject and its surroundings. How close are other objects to your subject? Move to a different angle so that distractions are not conflicting with the edges of your subject. Try telephoto focal lengths for really strong sharpness contrast.

Tripods and Camera Support

Camera movement during the exposure, even if slight, can cause the loss of fine details and the blurring of highlights. This is not a simple thing that only shows up in extreme blurring of the picture. You can actually have degradation in image quality when the picture still looks "okay" if seen apart from a really sharp image.

You must minimize camera movement in order to maximize the capabilities of your lens and sensor. A steady hold on the camera is a start. Fast shutter speeds, as well as the use of flash, help to ensure sharp photos, although you can get away with slower shutter speeds when using wider-angle lenses. However, when shutter speeds go down, it is advisable to use a camera-stabilizing device. Tripods, beanbags, monopods, mini-tripods, shoulder stocks, clamps, and more all help. Many photographers carry a beanbag or a clamp pod for those situations where the camera needs support but a tripod isn't available.

Check your local camera store when buying a tripod. Extend it all the way to see how easy it is to open, then lean on it to see how stiff it is. Both aluminum and carbon fiber tripods offer great rigidity. Carbon fiber is much lighter, but also more expensive. Yet, a quality carbon fiber tripod can be an excellent investment for the photographer. It is a relatively inexpensive way of getting consistently sharper pictures and it will last a long time.

Insider View: I sometimes find photographers very proud of their L-series lenses, yet they never use them on a tripod. I will guarantee consistently sharper photos with even the lowest-priced Canon lens compared to an L-series lens if that low-priced lens is used when the camera (or lens) is attached to a sturdy tripod.

The head is a very important part of the tripod and may be sold separately. There are two basic types for still photography: (1) The ball head and (2) the pan-and-tilt head. The biggest difference between them is the way you loosen the controls and adjust the camera. Both can offer solid support. They also come in different sizes. Be sure to get a tripod head that will support your 50D with a large telephoto zoom lens.

Try both types of heads at your camera store and see which seems to work better for you. Be sure to do this with a camera on the tripod because that added weight changes how the head works.

Working with the Computer

There are two main ways of copying digital files from the memory card into the computer. One way is to download images directly from the 50D using a USB interface cable (included with the camera at the time of purchase). The second way is to insert the card into an accessory known as a card reader. Card readers connect to your computer through the USB or FireWire ports and can remain plugged in and ready to download your pictures.

Direct from Camera

The advantage of downloading directly from the camera is that you don't need to buy a card reader, plus you can utilize the Transfer order menu item (in **\D***) to preset which photos you want to transfer from camera to computer. However, there are some distinct disadvantages in using the camera for transfer. For one, cameras generally download much more slowly than card readers (given the same connections). Plus, a camera has to be plugged into and unplugged from the computer for each use (the card reader can be left attached); you have to find a place for the camera where it won't be disturbed (or won't be in the way, either). As well as these drawbacks, downloading directly uses the camera's battery power—if the camera should lose power during the download, you could corrupt the data on the card and lose all the images not yet downloaded. If you download from a camera, you must to be sure the batteries are fresh or you need to plug it into AC power.

Photographing details of a subject can be a great way to approach a scene with your camera.

The Card Reader

A card reader can be purchased at most photo and electronics stores. There are several different types, including single-card readers that read only one particular type of memory card, or multi-readers that are able to work with several different types of cards. The latter is important with the 50D only if you have several cameras using different memory card types (the 50D uses only CompactFlash cards). After your card reader is connected to your computer, remove the memory card from your camera and put it into the appropriate slot in your card reader.

A memory card reader is a fast and convenient way to download your images.

Insider View: If you have only EOS D-SLRs, you can use a quality card reader for just CompactFlash cards (cheap, generic readers don't always work the way they should—also be aware that the fastest memory cards will download faster, but only if working with a newer card reader that supports them).

The card will usually show up as an additional drive on your computer (if not, you probably have an older operating system and may have to install drivers that likely come with

the card reader). When the computer recognizes the card, it may also give instructions for downloading—follow these instructions if you are unsure about opening and moving the files yourself, but this is much slower than simply selecting your files and dragging them to where you want them.

Insider View: Some computers have built-in card readers. These are convenient, but I have seen a whole range of speeds with them. Often a separate card reader is faster, but unfortunately, that can't be arbitrarily predicted.

Organizing Digital Image Files

How do you edit and file your digital photos so that they are accessible and easy to use? To start, it helps to remember that your computer's hard drive is simply an electronic filing cabinet. Just as you could file photos in cabinet drawers and folders, you can do the same thing virtually in the computer. It helps to create those "drawers" as overall (sometimes called parent) folders for things like the current calendar year, then create folders specific to groups of images, for example, categorized as XYZ Corporation, or Portraits, or Downtown Fair, or Acme Equipment Demo, etc.

Be sure to edit your photos and remove extraneous shots or poor pictures. Unwanted photos stored on your computer waste storage space on your hard drive and make it harder to find the images you do want to locate, so you should store only the ones you intend to keep. Take a moment and review your pictures while the card is still in the camera. Erase the ones you don't want, and download the rest. You can also delete photos once downloaded to the computer.

There are many ways to deal with this type of organization. You can work directly with your computer's folders and drives using your operating systems way of handling them, Windows Explorer or Mac Finder. You can also use a program to help you with this downloading. Adobe Photoshop, Photoshop Elements, and Adobe Photoshop

Develop a filing system that is meaningful to you and allows you to find your images, maybe into folders that are dated or categorized into such groups as "nature," "landscapes," or "family/friends." And be sure you back up your photos, so that you don't lose important pictures.

Lightroom all offer options that will automatically recognize a memory card and prompt you with options that will allow you to efficiently download images from the card and onto your computer. There are a number of programs like this available, as well as books about them, that will help you organize your pictures.

Here's one way to deal with digital camera files using the computer's file system. Open the memory card (that appears as a drive on your computer) as a window or open folder showing the images in the appropriate digital photo folder. This is the same basic view on Windows and Mac computers. Then open another window or folder on the computer's hard drive, and create a new subfolder labeled to signify the photographs on the memory card, for example by place, topic, or date. It helps to create all of these folders in a specific location on my hard drive—use a parent folder (the

"file cabinet") that you might call Digital Images. Then inside that, set up folders by year, then the individual shoots (you could use locations, months, whatever works for you). This is really no different than setting up an office filing cabinet with hanging folders or envelopes to hold photos.

Next select all the images in the memory card folder and drag them to this new folder. This copies all the images onto the hard drive and into the parent folder (filing cabinet), which is actually better than using a physical filing cabinet because you can use browser software to do things such as rename all the photos in that new folder, with titles that give information about each photo (such as Horsetail-FallsColGrgOR01), or quickly find a specific image with an electronic search.

You can also set up a group of folders in a separate parent folder/filing cabinet (a new folder at the level of Digital Images) for edited photos. In this you can include subfolders specific to types of photography, such as landscapes, closeups, people, etc. Inside the subfolders, you can break down categories even further when that helps to organize your photos. Inside these sub categories, place copies of original files that you have examined and decided are definite keepers, both unprocessed (direct from the camera) and processed images, keeping such files separate. Make sure these are copies (rather than simply moving the files here); it is important to keep all "original" photo files in the original folder that they went to when first downloaded. (Another way of doing this is to use cataloging software such as ACD-See, Photoshop Lightroom, or Microsoft Expressions; then you simply use keywords and other organizing tricks to create "virtual" folders or catalogs for your photos.)

Once you have downloaded your images onto the computer, back them up!!!! I can't emphasize this enough. I have two external hard drives just for this purpose. If all your images are on just the hard drive in your computer, you are asking for trouble. There are many external hard drive options. The key is to do it.

It also helps to burn key photos to a quality CD or DVD as soon as possible. CDs are too small for backing up large numbers of digital photos, so they are best used for important images. Be sure to use a quality, brand name CD-R (never CD-RW) for this back up. DVD is another alternative, although it sometimes is not 100% readable if you need to go from computer to computer.

Browser and Cataloging Programs

Photoshop CS3 was the first Photoshop program that had a browser, Bridge, that was actually fast enough to be useful for organizing photos. Bridge in CS4 has included some new features that really improve the browsing experience of this program and help you organize your pictures better.

My main program for organizing and working with pictures is Lightroom 2 (you will find information about it on my website, www.robsheppardphoto.com, and my blog, www.photodigitary.com). This program was designed by Adobe specifically for photographers. Photoshop is a very powerful program, but it was never designed specifically for photographers, rather for photography by a lot of different types of users. Lightroom allows you to organize, catalog, and process images far faster than you can ever do with Bridge and Photoshop.

Lightroom is a database program and includes very important features such as keyword input, keyword searching, ability to search via metadata, creation of collections and smart collections, and so forth. It allows you to quickly look at photos on your computer, edit them, rename photos one at a time or all at once, read all major image files, resize photos for emailing, create simple slideshows, print photos at varied sizes, and more.

Raw photos offer a great many possibilities for adjustment in the computer, especially helpful for pictures recorded in challenging light.

Image Processing

Of course, you can process the 50D's JPEG files in any image-processing program. One nice thing about JPEG is that it is one of the most universally recognizable formats. Any program on any computer that opens image files will recognize this format. Though you can use JPEGs directly from your camera or card reader, they can also be adjusted with image-processing programs to get more out of them.

RAW, as discussed earlier, is an important format because it increases the options for adjustment of your images. The big advantage to the RAW file is that it captures more directly what the sensor sees. It holds more information

(14-bits vs. the standard 8-bits per color) and can have stronger correction applied to it (compared to JPEG images) without problems showing. This can be particularly helpful when there are difficulties with exposure or color balance.

Canon offers a very good way of converting CR2 files to standard files with the Digital Photo Professional software that is included with your camera. Photoshop's Camera Raw, which comes with Adobe Photoshop and Photoshop Elements (though with fewer adjustments in the latter) and Photoshop Lightroom, offers convenient and high-level features for RAW conversion and workflow.

Digital Photo Professional Software

Digital Photo Professional (DPP) was developed to bring Canon RAW file processing up to speed with the rest of the digital world. This program now comes with the 50D and will work on all presently available EOS cameras. It can be used to process both CR2 files and JPEG files. DPP is fast, full-featured, and gives excellent results.

Storing Your Images

Even though digital images are stored as digital files, they can still be lost or destroyed without proper care. Many photographers use a second hard drive to store and safeguard image files, adding an external USB or FireWire drive. This allows you to immediately and easily back up photos on the second drive. It is very rare for two drives to fail at once.

Hard drives and memory cards are all devices known as magnetic media. As such, they do a great job at recording image files for processing, transmitting, sharing, and more. However, they are not good for long-term storage. Magnetic media have a limited life. Most manufacturers won't rate such storage devices beyond 10 years. This is a conservative number, to be sure, but this type of media has been known to lose data in that time span.

There are also a number of malicious computer viruses that can wipe out image files from a hard drive (especially JPEGs). Even the best drives can crash, rendering them unusable. Plus, we are all capable of accidentally erasing or saving over an important photo.

One answer to these storage problems is to use more than one accessory hard drive, so that at least one can be separated from your computer at times for protection. Another answer is optical media. A CD-writer (or burner) is a necessity for the digital photographer. DVD-writers work extremely well, too, and DVDs can handle about six times the data that can be saved on a CD. Either option allows you to back up photo files and store images safely.

There are two types of disk media used for recording data, but only one should be used for photo storage: R-designated (i.e. CD-R or DVD-R) recordable disks. CD-R and DVD-R disks can only be recorded once—they cannot be erased and no new images can be added to them. This makes them far more stable. The RW type of media (CD-RW and DVD-RW), on the other hand, can be recorded on and then erased and reused later, and you can add more data to them as well—this makes them inherently less stable. For long-term storage of your images, use CD-R or DVD-R disks, period.

Note: DVD comes in + and – types—be sure you get the right type for you computer or it won't record.

Insider View: Buy quality media. Inexpensive disks can fail within years. Read the box. Look for information about the life of the disk. Most long-lived disks are labeled as such and cost a little more.

Direct Printing

You can control the printing directly from the 50D with most Canon printers and many other brands that allow direct printing. The camera is PictBridge compatible (meaning that it can be directly connected to any PictBridge printer from other manufacturers). Most new photo printers are PictBridge compatible. With these printers, simply connect the camera to the printer using the dedicated USB cord that came with the printer. Do this connection when both devices are off.

Note: RAW files cannot be used for the direct printing options mentioned in this section.

Turn on the printer first, then the camera; this lets the camera recognize the printer so it is prepared to control it (some printers may turn on automatically when the power cable is connected). Depending on the printer, the actual direct printing features of the camera will vary.

Press the Debutton and use to select an image on the LCD monitor that you want to print. There will be an icon in the upper left to indicate the printer is connected. Press and the Print Setting screen will appear, giving such printing choices as whether to imprint the date, to include printing effects, number of copies, trimming area (cropping for the print), and paper settings (size, type, borders or borderless). Continue to use the and to set these options to the desired settings. Very important: These choices may change depending on the printer; refer to the printer's manual if necessary.

Insider View: The amount of control you have over the image when printing directly from the camera is limited entirely by the printer, and often you will have little or no control over color and brightness. If you really need image control, print from the computer.

Record JPEG images to allow you to take a picture and immediately print it direct from the camera with a PictBridge compatible printer.

If you are shooting a lot of images for which you plan to use direct printing, do some test shots and use the results to set up various Picture Styles that will help to optimize the images for direct printing. For instance, you may create a custom Picture Style setting that increases sharpness and saturation works well for your landscape photos.

Another area in which to experiment with direct printing is the use of printing effects. There are 10 different settings for these effects. (None of these effects are applied to the image file itself, only to the data that is being sent to the printer).

• On—this prints the image based on the printer's standard color settings.

- Off—no special adjustments are made for the printer's color settings.
- **Vivid**—adjustments will be made to increase the saturation of colors, especially blues and greens.
- **NR**—this is a noise reduction setting and will reduce noise in the printed image. Be careful of this as it can make an image look less sharp.
- **B/W B/W**—black-and-white printing that ensures you have a good, solid black in the photo.
- B/W Cool Tone—black-and-white printing that gives an overall cool or bluish tone to the picture, especially in the darkest tonalities.
- B/W Warm Tone—black-and-white printing that gives an overall warm or yellowish tone to the picture, especially in the darkest tonalities.
- Natural—if you look in the 50D manual, you will see that this adjustment says that it prints the image in the actual colors and contrast. That is "actually" impossible as a camera can only interpret the real colors and contrast of the world. I think Canon means that this printing is done straight from the camera using the colors and contrast that is captured by the camera. No adjustments are made to those colors or contrast
- Natural M—this is identical to *Natural* except that there are some manual refinements to the adjustments that you can make. This is a good setting to use as it will allow you to use the INFO. button to give you controls over adjusting brightness levels based on the histogram, and a "brightener" adjustment for backlit shots.
- **Default**—this is very similar to *Off*, although it will change the way prints are made with certain Canon printers because of the way they handle the default setting.

Digital Print Order Format (DPOF)

Another printing feature of the 50D is DPOF (Digital Print Order Format). This allows you to decide which images to print before you actually do any printing. Then, if you have a printer that recognizes DPOF, it will print those specifically chosen images automatically. It is also a way to select images on a memory card for printing at a photo lab. When you drop off your CF card with images selected using DPOF—assuming the lab's equipment recognizes DPOF (ask before you leave your card)—the lab will know which prints you want.

You can set the options you want with the 50D, choosing all or any combination of individual images. DPOF is accessible through by scrolling to *Print order*. Press and you will get to the Print order screen. There you will find *Sel.Image* highlighted. Press again and you will be able to choose the pictures that you want for this option. Or you can scroll to **By** or *All image* to select either all of the pictures in a folder or all of the photos on your card.

Or, from the Print order screen, select the *Set up* item in order to choose *Print type* (*Standard*, *Index*, or *Both*), Date (*On* or *Off*), and *File number* (*On* or *Off*). After setting your choices, press the button to return to Print order. From there, scroll to choose either *Sel.Image* or *All image*: The first choice allows you to scroll and select individual images to print from your memory card; the second selects all of the images on the card for printing. Press the *Print* selection when you are ready to print. RAW files cannot be selected for DPOF printing.

Index

A

A-DEP mode (see Automatic Depth-of-Field mode) AEB (see Autoexposure Bracketing) AE (autoexposure) Lock 33, 44, 111, 114, 142, 149-150, 176 AF-assist beam 112, 130 AF modes **131-132**, 133-134 (in Live View) AF point 33, 34, 44, 50, 102, 111, 112, **129-130**, 132-133, 141-143, 163 Al Focus AF 132 Al Servo AF 112, 114, 132, 157 ambient light 107-108, 139, 157, 164, 174-175, 178-179 Aperture-Priority AE mode (Av) 107, 115, **159-163**, 178-179 artifacts 22 Auto power off **41**, 103 Autoexposure Bracketing 44, 50, 102, 106, **151-152** Automatic Depth-of-Field mode **163**

В

backlight 203
Basic Zone 131, 138, **152- 158**, 174, 177
batteries 32, **51-53**, 54, 207
blur 109, 154, 155, 159-160, 162, 165-166, 181, 204
browser programs **212**buffer 62, 70, 136
built-in flash 34, 50, 112, 171, **174-175**, 181
Bulb Exposure 61, **167**

C

card reader 207, 208-209 Center-weighted average metering 144 cleaning camera 66-67 cleaning sensor 40, 50, 59-**60**, 103 see also self-cleaning sensor Close-up mode **156-157** CMOS sensor (see sensor) color cast 26, 78, 81, 185 color space 89, 102 color temperature 22, 66, 70, 72, 77 CompactFlash (see memory card)

compression 23, 93, 95-96 CR2 (see RAW) Creative Zone 152-153, **158-164**, 177-180 custom functions 104, **105-116**

D

depth of field 42, 161-162, 178, 202 depth-of-field preview 32, 35, 42, **161**, 163 DIGIC 4 15, 36, 57, 69, 81 diopter 7, **43** DPOF **219** drive modes 34, 50, **136-137**

E

erasing images **65-66**, 102, 103, 125 E-TTL **175-176**, 185, 187 Evaluative metering **141-143** exposure compensation 40, 44, 50, 102, 106, **150-151**

F

FE lock 44, 176-177 file formats 23-24, 69, 91-97, 213 filter effects 75-77 filters 26, 75-77, 83, 86-87, 172, 198-200, 201 flash 32, 34, 169-187 flash exposure compensation 34, 44, 50, 180 flash metering 175-177
Flash off mode 157
flash synchronization 34,
107, 172-173, 178, 179
focusing 42-43, 44, 111-114,
129-133, 135-136, 192-204
in Live View 49, 133-135
focusing manually 43, 131,
142, 202
formatting memory card 20,
63, 65-66, 103
Full Auto shooting mode 154

G

guide number (GN) 173-174, 184

Н

High-speed continuous shooting drive 50, **136-137**, 151-152, 157

Highlight alert 102, 120, **145-146**Highlight tone priority 44, 50, 110, **149**histogram 102, 120, 145, **146-149**

1

image processing in-camera 15, 23-24, 57-58, **69-96**, 109-110 post processing 152, **213-214**

image recording quality 50, **95-97**, 115, 116 image review 18-19, 101, 118-119, 120, 121, 146, 166 image size 23, **95-97** ISO **21-22**, 34, 38, 44, 50, 106, 110, **138-140**, 159, 161, 165, 173 J JPEG 15, 23-24, 58, 69-71, **91-93**, **95-97**, 101, 157-158, 213-214 L LCD monitor **18-19**, 21, 33, 36,38, **45-49**, 60, 65, 77, **99-103**, 127, 129, 137, 146, 216 LCD panel 34, 45, **51**, 60, 70, 106, 123, 131, 139, **142**, 161 Landscape Picture Style 72, 75, 77 Landscape shooting mode **156**, 174 lenses 30-31, 43, 56, 60, 67, 101, 111, 113, 114, 129, 135, 139, 165, 174, **189-**197 Live View 15, 33, 36, 42, **47-49**, 51, 61, 103, 116-117, 133-135, 172 Low-speed continuous shooting 36, 136, 154

M

magnification factor **55-56**, 189 Manual Exposure shooting mode (M) 38, 40, 150, **163-164**, 175, **179**, 180 memory card **19-20**, 23, 27, 30, 33, **62-66**, 70-71, 91, 93, 97, 101-102, 122-123, 207-208, 210-211, 214, 219 menus **99-105**, 116 metering 34, 36, 44, 49 (timer), 50, 111 (AE lock), 114, **141-144**, 103, 164, 176 see also flash metering Mirror lockup **61**, 90, **113** My Menu 37, 89, 90, 99

Ν

natural light 139, 175, 187 Night Portrait shooting mode 75, 157, 174 noise 15, 22, 36, 48, 54, 57, 109, 110, 138-140, 146, 152, 167, 192, 218 noise reduction 22, **109-110**, **140**, 167, 218

o

One-shot AF 40, 85, **112**, **131**, 134, 154, 156-157 overexposure alert (see Highlight alert)

P

Partial metering 141, **143**, 144
Picture Styles **72-77**, 91, 154, 217
playback (see image review)
Portrait shooting mode 139, **155**printing 25, 37, 71, 75, 89, 93, **216**, 218-219
Program AE shooting mode **158**, 178 (with flash)

Q

Program shift

Quality (see image recording)

protect images 102, 124

R

RAW 15, **23**, 24-25, 36, 58, 62, **69**, 73, 74, 77, 78-81, 89, **90-97**, 101, 136, 149, 154, 213-214

RAW+JPEG 23, **95-96**, **101**, 154

red-eye reduction 32, **181-82**remote switch 61, 167

reset 42
resolution 15, **24-26**, 29, 71, 95-97

S

self-cleaning sensor 15-16, 37, 40, **59** self-timer 37, 50, 61, 136-**137**, 151, 154 sensor 18, 23-25, 31, 36-37, 47-49, **54-58**, 69, 71, 82, 91-93, 95, 117, 129, 137-138, 148, 167, 189, 193-195, 199, 213 Shooting modes 47, 131, 138, **152-153** Shutter-Priority AE shooting mode (Tv) 107, **159**, **178** Single shooting drive 50, 61, **136**, 154, 156-157 Speedlite flash units (see flash) Sports shooting mode 157, Spot metering 36, 44, 141, 143, **144** sRaw 96

T

TIFF 79 tripod 45, 47, 61, 91, 113, 135, 137, 139, 144, 157, 165, 178, 189, 195, 202, **204-205** TV playback 95, **103–104**

U

USB 35, 37, 207, 214, 216

V

viewfinder 30, 33, 36, **42-44**, 48-49, 61, 70, 102, 112, 117, 134, 143, 144, 161 vignetting 42, 101, 198

W

white balance 26, 34, 44, 48, 50, **78-88**, 102, 107, 153